Glass

of four millennia

Martine S. Newby

Ashmolean Museum Oxford
2000

ISBN 1 85444 124 8 (papercased)
ISBN 1 85444 123 X (paperback)

Titles in this series include:
Ruskin's drawings
Worcester porcelain
Maiolica
Drawings by Michelangelo and Raphael
Oxford and the Pre-Raphaelites
Islamic ceramics
Indian paintings from Oxford collections
Camille Pissarro and his family
Eighteenth-century French porcelain
Miniatures
Samuel Palmer
Twentieth century paintings
Ancient Greek pottery
English Delftware
J.M.W.Turner

British Library Cataloguing in Publication Data
A catalogue record for this book is available from the
British Library

Cover illustration: *The Cuddesdon bowl*, no. 16

Designed and typeset in Versailles by Roy Cole, Wells
Printed and bound in the United Kingdom by Balding + Mansell
Limited, Norwich

Introduction

Part of the fascination of glass lies in the paradox that it is a fragile liquid. Made from a mixture of sand, a flux (such as soda or potash) and lime, when molten glass can be manipulated into a wide range of forms. Yet, when it passes from a hot liquid state to a cold solid state, it does not undergo any kind of internal structural change or crystallisation. Described frequently as a 'super-cooled liquid' or a 'liquid stone', glass is one of the most important and versatile man-made substances – transparent, impervious and relatively inert.

The Ashmolean Museum is fortunate to possess a collection of glass that spans from *circa* 1400 BC to the present day. Throughout its development the forms of and decorative motifs on glass have been influenced by those produced in other media, especially silver, pottery and rock-crystal. The objects included in this short book are drawn from the three major departments of the Museum: Antiquities, Eastern Art and Western Art, with an additional six Islamic glass weights from the Heberden Coin Room.

In 1893 the Museum received forty-one cases of Egyptian antiquities from Sir Flinders Petrie's excavations at Tell el-Armana. Among these was material from the sites of three or four 18th Dynasty glassworks of *circa* 1350 BC, which included fragments of crucibles, glass canes and rods, as well as pieces of typical colourful core-formed vessels decorated with combed trailing in contrasting colours.

Excavations by the University have also produced ancient glass as from the expedition to Faras, Egypt, during the 1920s. Since the 1870s the Antiquities Department has been given and bequeathed

large collections of Egyptian, Greek and Roman antiquities. These often contained glass, as with the numerous gifts made by the Reverend Greville Chester and the collection bequeathed by Henry Christy in 1874. Edmund Oldfield, formerly Librarian and Fellow of Worcester College bequeathed eighty-five glasses which included pieces from Idalion, Cyprus, that were formerly in the di Cesnola Collection, while the 1910 bequest of Oliver Wardrop, a diplomat, included glasses from Kertch, Crimea and from Carthage.

The ancient glass collections also include pieces found in England like the Wint Hill Bowl (no. 14), from Banwell, Somerset, and the Cuddesdon Bowl (no. 16), a very rare survival from Anglo-Saxon times. There is also a comprehensive collection of mid 17th- to later 18th-century sealed wine-bottles from Oxford taverns and colleges (nos 37–8), most of which were found during building work at the end of the 19th and early 20th centuries.

Donald Harden, one of the greatest scholars of ancient and medieval glass, worked in the Department of Antiquities, first as Assistant Keeper (1929– 1945) and then as Keeper (1945–1956). As Keeper he actively and systematically acquired glass whenever possible. These included whole vessels as well as interesting fragments mainly from older well-known collections like those of Sir Francis Cook and Sir John Evans, through dealers like Denis Haynes at Arthur Churchill Ltd and from auction-houses, especially Sotheby's.

The Department of Eastern Art has a small but representative collection of Islamic glass that demonstrates the skill and versatility of Near Eastern glass-makers from the 8th to the 15th centuries. These examples come mainly from two collections, those of Mr James Bomford and Mr Patel. There has also been a careful purchase policy over the last thirty years, often achieved with the help of funds from the Friends of the Ashmolean, like the acquisition of the gilt and enamelled mosque lamp of the Sultan Muhammad ibn Qala'un (1294–1340;

4

no. 31). There is also a small group of 18th-century Chinese glass including the two cameo-cut vases given by Mr and Mrs Hallam in 1997 (no. 51) and the Richard Arnold Collection of snuff-bottles given by Mrs Murray to the Museum in 1989.

The Renaissance and Continental glass holdings of the Department of Western Art are dominated by the twenty-five pieces bequeathed by C.D.E. Fortnum in 1899. These pieces, which include representative examples of the major forms and decorative techniques employed, complement his more extensive collections of Renaissance bronzes and maiolica.

The Department also has a collection of twenty-six Bohemian enamelled opaque white *Milchglas* (milk glass) beakers, tankards and vases that were bequeathed by Gerald Reitlinger in 1978. These, however, suffered greatly during a house-fire, and are only a small part of his collections that also comprised Far Eastern and European ceramics.

The Museum's holdings of late 17th- and 18th-century English glass are large, comprising over 750 pieces. They come principally from two collections that entered the Ashmolean between 1948 and 1957. The first was a bequest of 122 glasses from Sir Bernard Eckstein, a wealthy business man who had attended Trinity College, Oxford. He formed his collection by purchasing more striking pieces from auctions of other important collections through Cecil Davis, one of the leading London glass dealers of the time.

Mrs Monica Marshall's collection of English glass is more eclectic. It comprises nearly 500 pieces that range from simple tavern glasses, oil-lamps and jelly glasses to more elaborate pieces like the baluster goblet engraved with the Fall of Adam and Eve (no. 40) and the pair of stipple-engraved portrait goblets by David Wolff (no. 49). The latter two were presents from her husband, Henry Rissik Marshall, whose famous collection of Worcester porcelain was also given to the Ashmolean in 1957 in memory of their only child, Lieut William

Somerville Marshall, who had been killed during the Second World War.

The fifty-six pieces illustrated here are representative of the holdings of the Ashmolean but because most of the Museum's objects have been acquired through gifts and bequests, some areas are consequently better represented than others. It is hoped that the descriptions of the selected glass objects will provide a guide to the development and styles of decoration employed over the last four millennia.

Acknowledgements

The author is grateful to the many members of staff of the Museum who have contributed their knowledge. I would like to thank especially Dr Arthur MacGregor, Michael Vickers and Dr Helen Whitehouse from the Department of Antiquities; Professor James Allan and Shelagh Vainker from the Department of Eastern Art; Dr Luke Treadwell from the Heberden Coin Room, and Catherine Casley and especially Timothy Wilson from the Department of Western Art. The entry for nos. 47–8 is based on work by Charles Truman and no. 50 by Timothy Wilson. I would also like to thank Dr Marian Wenzel for the reproduction of her drawing of the early Islamic lustre fragments and Laurence and Simon Whistler for the inclusion of their stipple-engraved bowl. All the photography was undertaken by David Gowers with great care and skill.

Glossary

Annealing: Process in which a finished object is placed in a heated chamber or a specific area of a furnace and cooled gradually in order to reduce the internal stresses that can build up in a glass during manufacture and cause them to form strain cracks or break afterwards.

Batch: Molten mixture of raw materials that form glass, which is composed of three basic ingredients: silica obtained from sand, an alkali flux and lime.

Blow-pipe: A long narrow iron tube with an expanded terminal used to collect a mass of molten glass from a crucible and then inflate it to form a paraison.

Cameo glass: Vessel or an object made in layers of coloured glass in which the outer layer or layers are cut away to leave a design in relief, as on gemstones.

Cane: A long, usually circular glass rod that can be cut into slices, sections or lengths to make mosaic glass.

Flashing: Technique of applying a thin glass layer of contrasting colour to an object by dipping it into a crucible containing molten glass of the outer colour.

Flux: An alkali substance added to the batch to lower the melting point of silica. The most common fluxes are soda (sodium carbonate) and potash (potassium carbonate).

Lattimo: Opaque white glass; the name derives from the Italian word for milk, *'latte'*.

Lead-glass: Type of glass containing a large amount of lead oxide (24–30%) which is consequently more brilliant, softer and better suited for cutting.

Marvering: Technique of rolling hot and malleable glass over a flat surface, known as a marver, either to smooth the vessel walls or pick up and consolidate applied decoration.

Mosaic: Type of glass made up from sections of pre-formed patterned canes of glass that were re-heated until they fused together and then formed into the desired shape.

Mould-blowing: Technique of blowing a paraison of hot glass into a wooden, terracotta or metal mould of two or more parts either to create a particular form or to add decoration that can be further inflated to reduce the sharpness of the design.

Paraison: Bubble of molten glass formed on the blow-pipe through inflation after the initial amount of glass has been taken up from the crucible.

Stipple-engraving: Technique of tapping the surface of a glass with a pointed implement (usually incorporating a diamond) to produce a pattern of tiny dots that build up to make a picture, the greater the density of dots the lighter the design.

Abbreviations

AN	Department of Antiquities
EA	Department of Eastern Art
HCR	Heberden Coin Room
WA	Department of Western Art

1 Mosaic glass beaker
Mesopotamia, late 15th to early 14th century BC
Found in 1966 during the third season of excavations at Tell al-Rimah, Iraq

The technical knowledge for making glass was probably first developed in Mesopotamia from the use of vitreous glazes to cover pottery and beads towards the end of the third millennium BC. These three fragments are all that survive from one of the earliest types of glass vessel known. The almost cylindrical beaker they are part of was formed from circular sections, each with a diameter of *c.* 3.5 mm, cut from pre-formed solid, monochrome canes made in four opaque colours: red (now weathered to a light green), white, blue and yellow. These sections were built up and arranged into zigzag bands of a single colour over a hard core or mould and then re-heated sufficiently to fuse them together, while held in place by an outer mould. Afterwards the inner and outer surfaces were polished.

The shape (see figure below) was reconstructed by Donald Harden as a conical beaker with a knobbed base on the analogy of Nuzi pottery. The chevron pattern on this beaker is only found on other fragments from Tell al-Rimah while concentric lozenges occur on similar mosaic glass beakers and bowls from Aqar Ouf and Marlik in north-western Iran dating from the 14th century BC.

Greatest extant dimension 8 cm; rim diameter *c.* 8.5–9 cm
AN 1966.182a–c. Gift of the British School of Archaeology in Iraq

Bibliography:
Annual Report 1966, p. 14; D.B.Harden, 'Ancient glass, I: Pre-Roman', *Archaeological Journal* 125 (1968), pp. 47, 50, fig. 1, pl. 1b. Cf. A. von Saldern, 'Mosaic glass from Hasaniu, Marlik and Tell al-Rimah', *Journal of Glass Studies* 8 (1966), pp. 9–25 and D.P.Barag, *Catalogue of Western Asiatic Glass in the British Museum* Vol. 1 (London 1985), pp. 40–1, no. 4, for fragments from the same or a very similar vessel from Tell al-Rimah

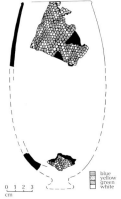

0 1 2 3
cm

blue
yellow
green
white

Reconstruction of beaker after Harden 1968, fig. 1

8

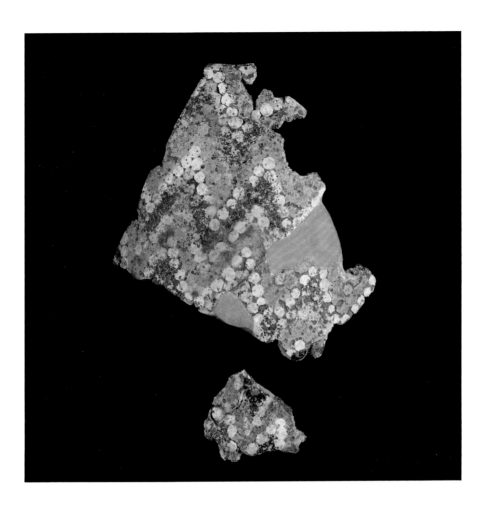

2 Fish-shaped dish
Egypt, late Eighteenth Dynasty (*c.* 1400–1300 BC)

Shortly after their appearance in Mesopotamia, glass vessels were introduced into Egypt. This was possibly as a result of campaigns conducted by Tuthmosis III (1524–1518 BC) in Upper Syria after which glass-makers may have been brought back to Egypt as captives. The production of core-formed vessels as well as inlays and other simple pieces was probably a royal monopoly during much of the New Kingdom, and the remains of several contemporary glass workshops have been found at Thebes and Tell el-Armana.[1]

Dishes or scoops in the shape of the *tilapia* fish, similar to those used for cosmetics but coming from exclusively funerary contexts, are familiar items in Egyptian collections. The *tilapia* was a symbol of birth and renewal: the connection may have been suggested by the observation of its distinctive breeding habits, whereby the eggs are hatched in the mother's mouth, from which tiny new fishes are seen to emerge. Most commonly the dishes are made of stone, but examples are also known in wood, bone, clay and faience.

This is an apparently unique example of such a dish in glass. The apple-green colour links it to faience of the same shade, made for only a brief period during the New Kingdom. An analysis of the components of the glass compares well with the published analyses of green faience, indicating that copper- and lead-oxide were used as colourants. Its 'crumbly' texture suggests that it was made by refiring powdered glass at a low temperature in a mould before details were engraved afterwards when cold.

Length 5.9 cm
AN 1989.85. Purchased with the aid of the Friends of the Ashmolean

Bibliography:
Annual Report 1988–1989, p. 22, pl. Ib; *The Ashmolean* 17 (1989–1990), p. 24

[1] Fragments of glass-making waste from Sir Flinders Petrie's excavations at Tell el-Armana may be seen in Gallery 8.

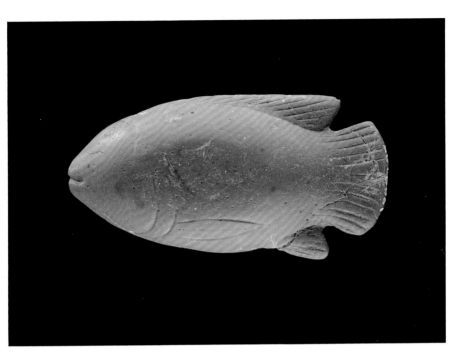

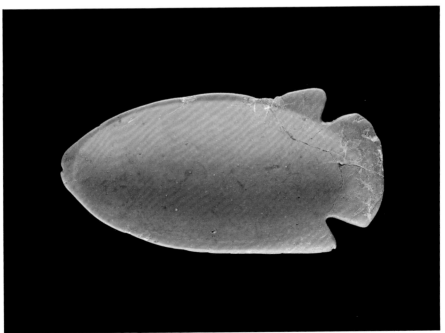

11

3 Core-formed alabastron
Eastern Mediterranean, 5th century BC
Found in a cemetery in the Milesian colony of
Nymphaeum, Crimea

The name 'alabastron' is derived from the fact that
many similarly-shaped perfume vessels were made
from alabaster. This glass example was made by coating
a core, probably made of clay mixed with animal dung
around the end of a metal rod, with molten glass.
Decorative coloured glass trails were then wound round
the core and 'marvered' (smoothed) on a flat stone slab
before being combed into festoons or zigzags, as here.
After annealing, the rod was removed and remnants of
the core picked out to create a hollow for the contents.
Other core-formed glasses made for unguents and per-
fumed oils take the form of contemporary ancient Greek
pottery shapes like the hydria (water-pot) and oenochoe
(wine-jug).

The colours of this piece – reddish-brown with
opaque light turquoise-blue and yellow trailing – are
more unusual; most examples have a deep lapis-lazuli
coloured ground, in evocation of that stone, with
opaque white and yellow trailing. Their place of manu-
facture is unknown – examples have been found
throughout the Mediterranean world, especially from
the eastern part, and in the northern Black Sea area.
The high concentration of finds on the island of Rhodes
suggests that their production centre was located some-
where in the Aegean or along the coast of Ionia.

Height 10.6 cm
AN 1885.501. Gift of Sir William Siemans

Bibliography:
M. Vickers, *Scythian Treasures in Oxford* (Oxford 1979), pl. 17. On
the technique of manufacture, cf. B. Gudenrath in H. Tait (ed.) 1991,
pp. 214–15, figs 1–15, and E. M. Stern and B. Schlick-Nolte 1994, pp.
37–44

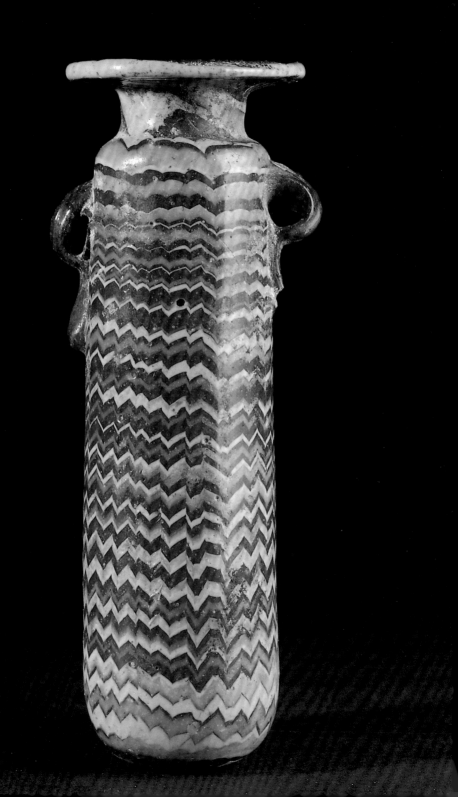

4 Hellenistic blue cast bowl
Eastern Mediterranean, 2nd century BC

Hemispherical bowl cast in opaque blue glass with a slightly everted rim and decorated with wheel-cut grooves on the exterior. The shapes of these early cast glasses were influenced by contemporary silver and pottery vessels. Grooved bowls like this were made from a flat disk of hot glass that was slumped over a hemispherical mould and then, when cold, polished on the interior and decorated with wheel-cut grooves. In the case of mosaic wares, the flat disk was assembled from many sections cut from pre-formed patterned canes that were fused together before being slumped over the mould.

 The opaque white on the upper body and interior of this bowl is not part of the original glass but weathering caused by chemicals leaching out from the glass reacting with those present in the soil in which it was buried. Often this weathering takes the form of iridescence, as can be seen on nos 10 and 26, a phenomenon copied by Art Nouveau glass-makers like Tiffany at the end of the 19th century.

Height 4.5 cm; rim diameter 10.6 cm
AN 1953.48. Purchased from Spink's, London

Bibliography:
Annual Report 1953, pp. 25–6, pl. IIIa. For the technique of fusing and slumping cf. B. Gudenrath in H. Tait (ed.) 1991, pp. 219–21, figs 36–58

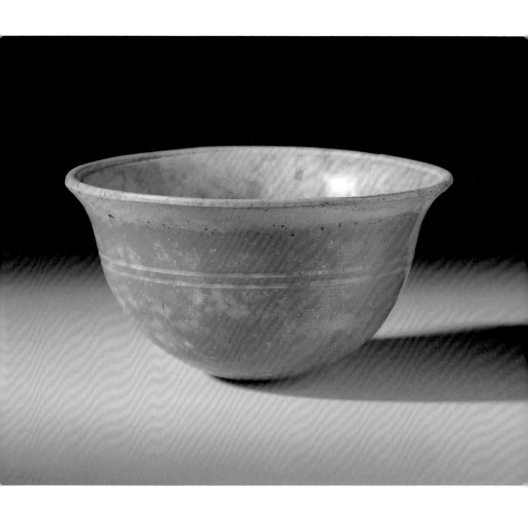

5–9 Ptolemaic mosaic glass inlays
Egypt, 1st century BC – 1st century AD

These inlay pieces look far more complicated than they really are, as anyone who has played with modelling-clay will know. Suitably shaped canes of glass were bundled together as appropriate, then fused together, marvered and stretched to form long bars from which identical slices could be cut. The technique seems to have had its origins in Phoenicia, where sections of composite bars were used for inlays in furniture and other wooden objects. It was further developed in Ptolemaic Egypt, where highly skilled craftsmen were able to incorporate minute designs. Here we see a frieze of water plants, *ankh* and *was* symbols, bound prisoners, and two theatre masks: three motifs from the traditional Egyptian repertoire, and two from the classical Greek.

5. Fragment of a tile with Nilotic plants including lotus fruits.
Height (surv.) 10.7 cm; width (max.) 5 cm
AN 1910.481. From Ihnasya, Middle Egypt

6. Opaque white and yellow open-mouthed comic theatre mask in a red background.
Height (surv.) 1.7 cm; width (surv.) 1.3 cm
AN 1965.323a. Purchased from the Trustees of Captain E.G. Spencer-Churchill

7. Opaque white hieroglyphs, an *ankh* flanked by two *was* symbols, in a blue matrix, that read, ' all life and power' on a *neb* basket.
Height (surv.) 1.85 cm; width 1.5 cm
AN 1965.324. Purchased from same collection as no. 6

8. Three male prisoners, bearded and naked, with their arms and legs tied behind them and around a papyrus column.
Height 2.4 cm; width (max.) 2.4 cm
AN 1965.321. Purchased from same collection as no. 6

9. Half a female tragic theatre mask with an opaque white face and brown curled hair in a turquoise-blue matrix.
Height 3 cm; width 1.4 cm
AN 1965.322a. Purchased from same collection as no. 6

Bibliography:
For comparable examples cf. Christie's, *Ancient Egyptian Inlays from the 'Per-neb' Collection, Part II*, auction catalogue (London, 7 July, 1993) and E.M. Stern and B. Schlick-Nolte 1994, pp. 59–63, 360–416

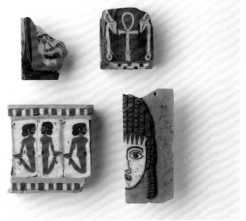

10– Two Roman splashed vessels
11 North Italy or eastern Mediterranean, second half 1st century AD

In the middle of the 1st century BC glass-makers along the Syro-Palestinian coast discovered that molten glass could be inflated with air through a hollow blow-pipe. This invention of 'free-blowing' revolutionized the glass industry. It allowed vessels to be mass-produced thus rendering them less expensive and available to a wider market so that by the end of the 1st century AD free-blown glass vessels were used widely throughout the Roman Empire. The majority were undecorated utilitarian pieces, used for storage and transport, and tablewares, like beakers and plates, but others, like these two vessels, were embellished with applied decoration. While still hot their bodies were rolled over loose glass chips of contrasting colours and then marvered flush with the wall of the vessel. Next, the pieces were reheated and further inflated and manipulated, so that when their necks were pulled out of their bodies the splashes also became elongated.

10. Small pale blue amphora with opaque white and yellow splashes. The two handles were added on top of the decoration.
Height 12.5 cm
AN 1945.127. Purchased from Spink's, London

11. Small pale purple handled glass bottle with a bulbous body and decorated with opaque white marvered splashes.
Height 13 cm
AN 1947.170. Purchased from the Cook collection

Bibliography:
Annual Report 1945, p. 12, pl. Id and *ibid*. 1947, p. 20, pl. IIb (far right). On the technique of manufacture cf. B.Gudenrath in H. Tait (ed.) 1991, p. 226, figs 88–92

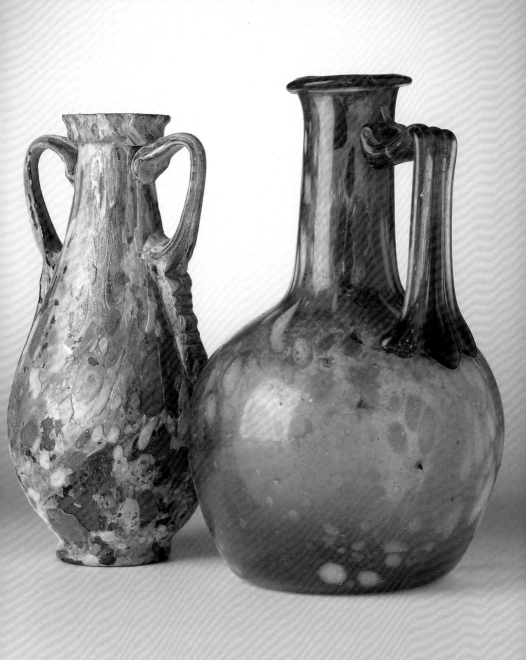

12– Two Roman barrel-shaped bottles
13 France, 2nd to 3rd century AD
Found at Amiens, France

Following on shortly after the invention of free-blowing was the discovery that molten glass could be blown into patterned moulds made of metal, wood or terracotta. Multiple moulds permitted the production of identical vessels at several different centres, possibly by itinerant glass-blowers. The early luxury mould-blown table-wares of the early 1st century AD were often signed but it is uncertain whether these names, such as Ennion and Artas, refer to the mould-maker or whether they served as an advertisement for the workshop.

These two 'prismatic' bottles are utilitarian pieces made for transporting and storing oil, wine and other liquids. They are made in naturally-coloured light green and bluish-green glass and were blown into moulds shaped like wooden barrels. The bases were also mould-ed and bear the letters 'FRON' or 'FROTI'. These are abbreviated forms of 'Frontinus', the name of a Gallo-Roman glass-maker active in the region around Amiens in Normandy from the end of the 1st century AD. Examples have been found across northern France, England, Belgium and the Rhineland in contexts dating up to the 4th century AD.

12. Pale bluish-green two-handled barrel-shaped bottle, the base with an inscription FRON (see right).
Height 18.8 cm
AN 1948.37. Formerly in the collection of Sir J.Evans and purchased from Arthur Churchill Ltd, London, together with no. 13 and a Hellenistic amber-coloured cast bowl

13. Single-handled barrel-shaped bottle made in pale green glass with the inscription FROTI on the base (see below right).
Height 17.4 cm
AN 1948.36. Provenance as for no. 12

Bibliography:
Annual Report 1948, p. 22, pl. Va and c. For further examples and variations cf. G.Sennequier, *Verrerie d'époque romaine* (Rouen 1985), pp. 168–81, nos 259–80

Underside of no. 12

Underside of no. 13

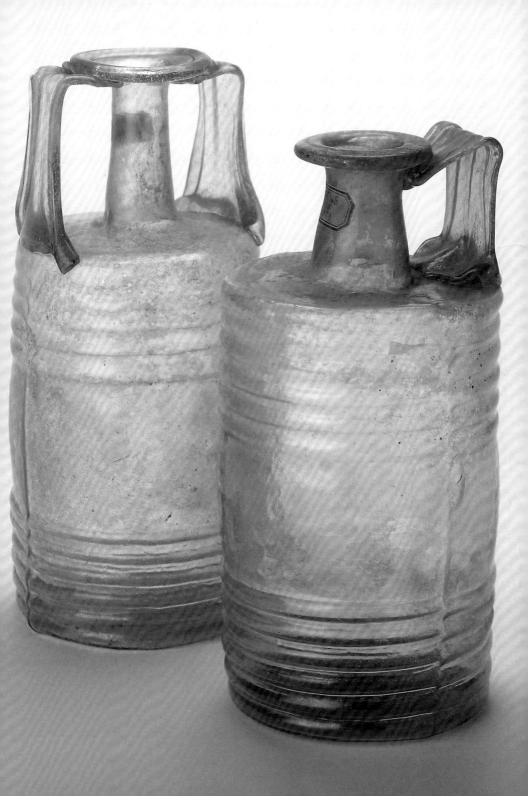

14 Wint-Hill hunting bowl

Rhineland, second quarter of 4th century AD
Found at Wint Hill, Banwell, Somerset.

This bowl was found by amateur archaeologists in a Roman building at Wint Hill, near Banwell, Somerset. It is a shallow vessel of greenish glass, whose segmental profile is the result of having been made from an inflated paraison or bulb of glass whose bottom segment was knocked-off. The rim is slightly everted and the edge smoothed so that it could be used as a drinking vessel.

The scene engraved on the outer surface (but intended to be seen from the inside) is a hare-hunt: a hare is driven into a net by a horseman and two hounds. Around the edge in Roman letters is an inscription comprising the Latin motto, 'VIVAS CUM TVIS' (Life to you and yours) and the Greek toast, 'PIE Z[ESES]' (Drink and good health to you). A bowl like this would have been a cheap substitute for rock crystal. Most similar bowls with hunting, mythological or Christian scenes, engraved roughly with a flint tool, have been found in the Rhineland which suggests that they were made in the important glass centre of Cologne.

Height 4.3–6.6 cm; rim diameter 19.0–19.3 cm
AN 1957.186. Purchased with funds from the George Flood France Bequest and with the aid of the National Art Collections Fund

Bibliography:
Annual Report 1957, p. 20, pl. V; D.B.Harden, 'The Wint Hill hunting bowl and related glasses', *Journal of Glass Studies* 2 (1960), pp. 44–81

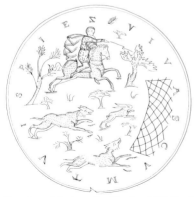

Drawing of design after Harden 1960, fig. 2

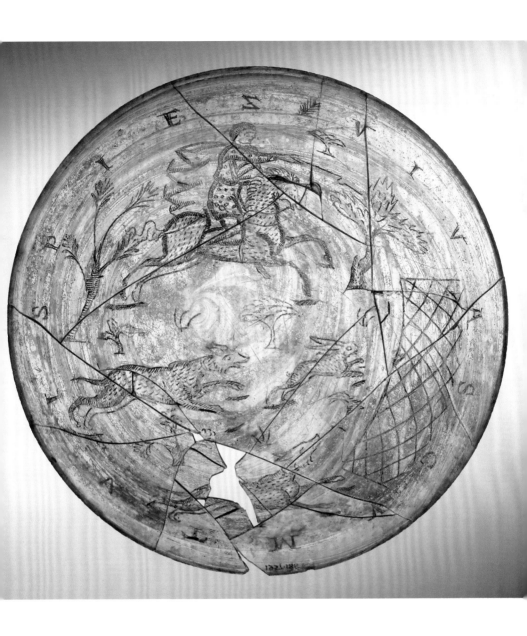

15 Gold-glass bowl fragment
Rome, 4th century AD
Rome, Italy. Found in the Catacombs

In antiquity glass was used for the manufacture of attractive-looking but inexpensive items. In this example, extremely thin gold-leaf was applied to the bottom of a bowl and then cut with the desired design before being protected or 'sandwiched' under a clear disc of glass. Details were sometimes further highlighted in red or white paint. The technique can first be observed in 2nd-century BC bowls from Canosa, Italy, that have a similar form to no. 4.

In the catacombs of Rome during the 4th century AD gold-glass medallions from the bottom of bowls, like this example, were seemingly broken away deliberately from the body of the vessel and inserted into the plaster which sealed the tomb niches, thereby serving as grave markers. These medallions have mostly Christian or Jewish scenes or symbols, often relating to marriage. This is a specially elaborate example: in the central medallion, are busts of a married couple and a Greek inscription, 'PIE ZE SES' (Drink and Good Health to you); radiating from it five popular scenes from the Old and New Testaments: Christ healing the paralytic, the raising of Lazarus from the dead, Adam and Eve standing either side of the Tree of Knowledge, Abraham about to sacrifice Isaac and lastly, Moses striking water from the rock in the desert.

Diameter 10.8 cm
Pusey House Loan 65. Wilshere Collection

Bibliography:
C.R.Morey, *The Gold-Glass Collection of the Vatican Library, with Additional Catalogues of the Other Gold-Glass Collections* (Vatican City 1959), p. 62, no. 366, pl. XXXI

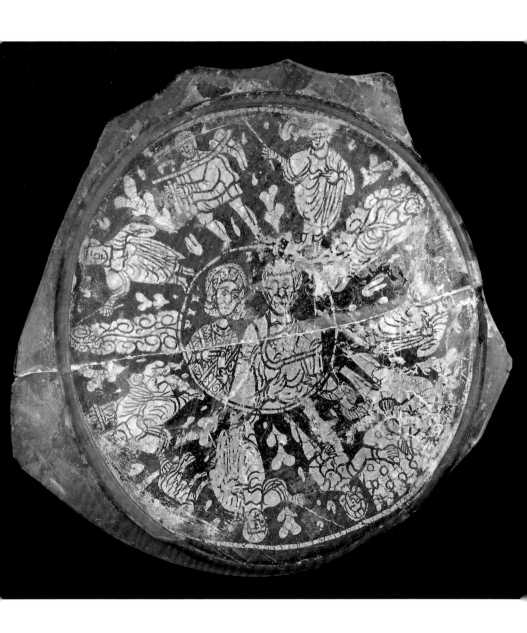

16 The Cuddesdon bowl
Anglo-Saxon, probably made in Kent, early 7th century AD
Found at Cuddesdon, Oxfordshire

This dark blue squat jar or bowl is a remarkable survival from the Dark Ages, when glass vessels were much rarer and more crudely formed than during Roman times. Around the upper part is a thin applied trail arranged in ten tight spirals while the lower part of the body is adorned with thirteen vertical loops. The bowl was discovered in 1847 in an Anglo-Saxon grave of noble rank during alterations in front of the gateway of the Bishop of Oxford's palace at Cuddesdon. It was found together with another blue glass bowl with thicker zigzag trailing (see figure below), a bronze bucket, and an inlaid bronze plaque. They may well have formed part of a princely burial. The bowl went missing after the effects of Bishop Wilberforce were sold, but was rediscovered in 1971 in a house in Leicestershire where it was being used as a flower vase.

Height 9.1 cm; greatest diameter 11.5 cm
AN 1980.269. Purchased with the aid of grants from the National Art Collections Fund, the MGC/V&A Purchase Grant Fund, and the Friends of the Ashmolean

Bibliography:
Anon., *Archaeological Journal* 4 (1847), pp. 157–9; J.Y.Akerman, *Remains of Pagan Saxondom* (London 1855), pp. 11–12, pl. VI,1; D.B. Harden, 'Glass vessels in Britain and Ireland, AD 400–1000', in D.B. Harden (ed.), *Dark Age Britain. Studies Presented to E.T.Leeds* (London 1956), pp. 141–2, no. 13, type VIII,a,iii; T.M.Dickinson, *Cuddesdon and Dorchester-on-Thames: Two Early Saxon 'Princely' Sites in Wessex*, British Archaeological Reports 1 (Oxford 1974), pp. 12–15, pls 1–2

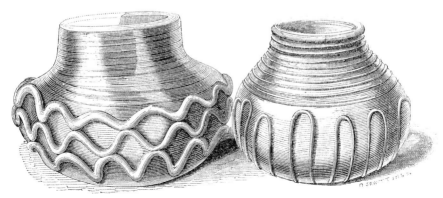

The two glass bowls from an engraving by O.Jewitt in *The Archaeological Journal* 4 (1847), fig. on p. 157

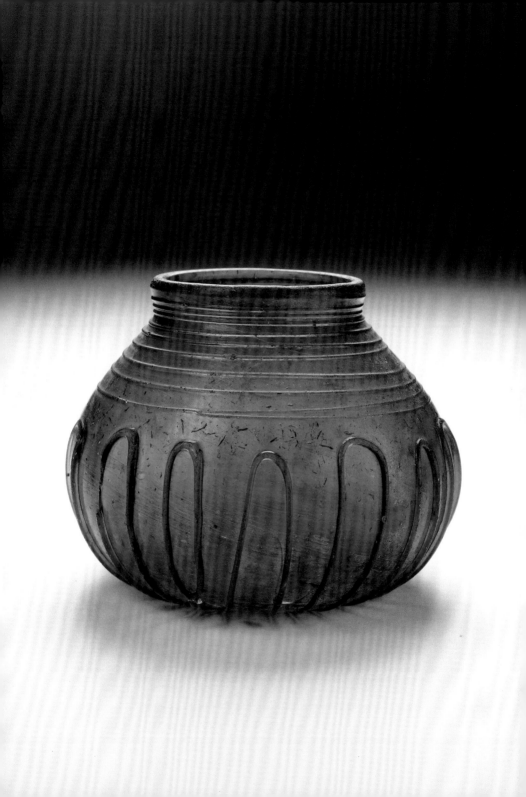

17– Two Byzantine medallions
18 Venice or Constantinople, 13th century

There are over 180 mould-pressed Byzantine glass medallions known which have been identified as coming from about sixty different moulds. Most of these pieces have Christian iconography, especially depictions of saints, many of which are identified by Greek or Latin inscriptions. Although they have a wide distribution, their homogeneity has led scholars to conclude that they probably had a single production centre, with Venice or Constantinople as the most likely. They are also related to Byzantine seals as well as early Islamic glass weights (cf. nos 19–24).

These two medallions are made in opaque brick red glass with brown and black striations and represent St Demetrius and St Christopher respectively. St Demetrius, who like St George is depicted as a warrior saint, was adopted as the patron saint of Thessalonica. He is armed with a spear and carries a small circular shield on which there is a Greek cross and is identified by the inscription 'OΔHMHTPIOC'. St Christopher, the former patron of travellers, is likewise shown frontally. He carries a staff in his left hand with the Christ-child sitting on his right shoulder, and his name is given in Latin, 'S CRIS[T]OFORI'.

17. St Demetrius medallion.
Height 3.15 cm; width 2.8 cm
AN 1941.81. Purchased in Jerusalem. Presented by Mrs W. Twining

18. St Christopher medallion.
Height 3.15 cm; width 2.8 cm
AN 1890.653. Purchased in Athens. Presented by the Rev. Greville Chester

Bibliography:
H. Wentzel, 'Das Medaillon mit dem Hl. Theodor und die venezianischen Glaspasten im byzantinischen Stil', in *Festschrift für Erich Meyer zum sechzigsten Geburtstag 29 Oktober 1957* (Hamburg 1959), pp. 50–67; M. Vickers, 'A note on glass medallions in Oxford', *Journal of Glass Studies* 16 (1974), pp. 18–21, figs 4 and 5 on p. 20. For examples in the British Museum cf. D. Buckton, 'Twelve medallions', in H. Tait 1979, pp. 13–15

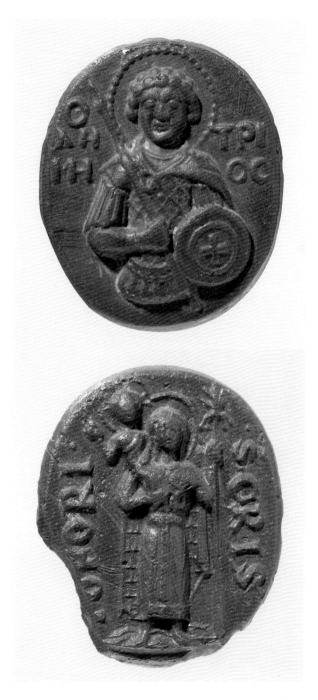

19– Islamic glass weights
24 Egypt, 7th to 12th century AD

All the small glass objects shown here have stamped inscriptions in Arabic, often with the names and title of the Caliphs, and belong to a series of glass weights based on the gold *dinar* (4.25 gm) or the silver *dirham* (2.97 gm) produced in Egypt from the 7th to 15th century AD.

19. Circular green *fals* weight with a square stamp inscribed, 'In the name of Allah. Abd al-Malik bin Yazīd ordered the weight of a *fals*, of 23 *kharrūba*'. Abd al-Malik was Governor and Finance Director between AH 133–6 and 137–41 (AD 751–3 and 755–8).
Max. diameter 27.2 mm; weight 4.4 gm
HCR Chester. 1892.1

20. Small opaque white *dirham* weight inscribed, 'Al-Imam al-Mustadi bi-amr Allah'. AH 566–75 (AD 1178–87).
Max. diameter 21.8 mm; weight 2.9 gm
HCR 1952.10.30.1. Purchased from Mrs Steward

21. Heavy green ring weight of a quarter-raṭl, with a circular stamp inscribed, 'In the name of Allah. Of what ordered the Amir Yāzid bin 'Abdallāh, freedman of the Caliph'. Yāzid was first appointed Governor on behalf of al-Muntasir, AH 242–53 (AD 856–67).
Height 42.5 mm; max. width 44.5 mm; weight 94.3 gm
HCR Chester. 1890.1. Found in Cairo

22. Light green weight inscribed, 'In the name of Allah. Amir Yazīd binḤātim ordered the weight of a *dirham*, (thirty?) full-weight'. AH 144–52 (AD 762–9).
Max. diameter 24.7 mm; weight 2.84 gm
HCR 1912.12.13.2

23. Large light green weight inscribed, 'In the name of Allah. Of what ordered al-Qāsim bin 'Ubaydallāh. A weight of a *fals al-kabīr* of 30 *kharrūba*, full-weight'. Al-Qāsim was Finance Director from AH 120–8 (AD 734–42).
Max. diameter 34.2 mm; weight 5.82 gm
HCR Chester. 1892.2

24. Small half *dirham* in dark olive green glass, appearing black, inscribed 'al-Mustansir Billah amir al-mu'minin', AH 427–487 (AD 1041–1101).
Max. diameter 19 mm; weight 1.49 gm
HCR 1912.12.13.1

Bibliography:
Cf. A.H. Morton 1985 and especially p. 63, nos 74–6 (for no. 23) and p. 128, nos 359–61 (for no. 21)

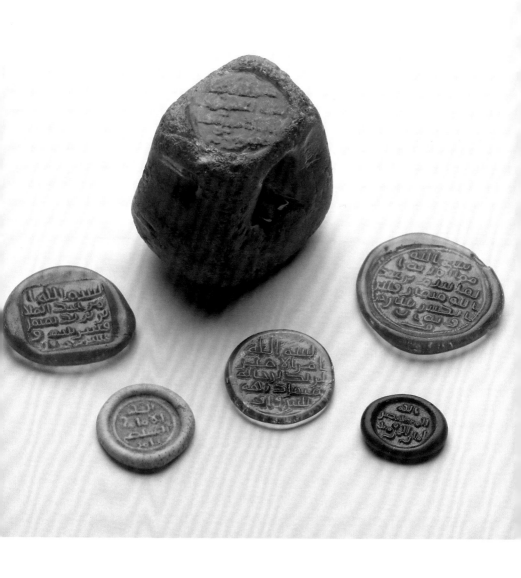

25 Early Islamic lustre fragments
Egypt. 8th century AD
Found in Fustat (medieval Cairo), Egypt

These sherds come from a rare hemispherical glass vessel decorated with lustre pigment. This decorative technique was probably invented by Egyptian glass-makers in the 8th century. It involved painting a finished cold vessel with metallic oxides that, when re-fired at a lower temperature ($c.$ 600°C) so as not to soften or deform the glass, would be covered with an extremely thin metallic sheen. This effect is probably best-known on Islamic pottery dating from the 9th to 14th centuries AD and on Hispano-Moresque wares from the 13th century.[1]

On this vessel both the inside and outside surfaces were painted with a bird, possibly a peacock (shown) and a rabbit or hare separated by stylized vegetation. Below the rim is an inscription in Kufic between two parallel lines painted on the outside only. The lustre pigment on this piece varies from pale yellow to chestnut brown depending on the thickness of its application. In addition, the lustre applied to the inside appears paler and more green because it is viewed through the glass which itself has a bluish-green tinge. To create a more naturalistic effect, details and shading have been scratched with a sharp-pointed tool.

Diameter $c.$ 11 cm
EA 1974.44. Found during the 1973–1974 season, no. 72-12-10.
Presented by the American Research Centre in Egypt

Bibliography:
M.Wenzel, 'Manuscript sources for some motifs in early Islamic glass painting', *Journal of the Royal Asiatic Society of Great Britain and Ireland* (1986), pp. 214–27

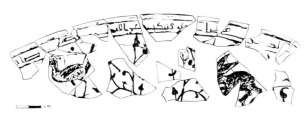

Drawing of all twenty-six surviving fragments after Wenzel 1986, fig. 2 on p. 215

[1] Cf. J.W. Allan, *Islamic Ceramics* (Oxford 1991), nos 3, 15–16, 23–24 and 28.

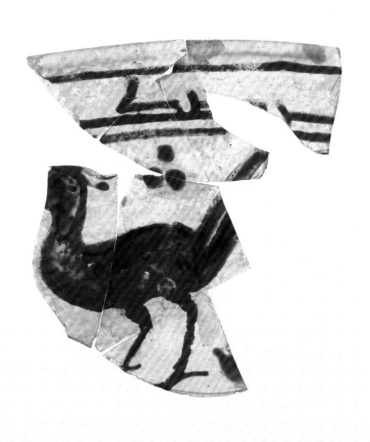

26 Islamic cut glass jug
Iran or Iraq, 9th–10th century AD

Under the Sassanian emperors (AD 247–645) in Persia thick-walled glass vessels like bowls and bottles were decorated with rows of deep wheel-cut facets arranged in staggered rows or quincunx. These pieces were highly prized and one example was even included in the tomb of the Japanese emperor Anhan (c. AD 550–600). They were made in imitation of more expensive rock crystal and in turn influenced early Islamic cut glass vessels like this jug. Although many of the techniques used in Islamic glass production were a continuation of those used in the late and post-Roman period we know much less about them. Glass vessels were not included in burials as the Muslim faith prohibits the inclusion of grave-goods with the dead. Some pieces, however, have survived intact like those preserved in European cathedral treasuries, most notably that of St Mark's, Venice, which includes works of art looted from Constantinople in 1204 after the Fourth Crusade.[1]

The decoration on this restored jug is 'bevelled cut', a technique that involved cutting the glass on a slant with a rotating wheel fed with an abrasive so that the ornament is raised up from the body of the vessel. The design of raised disks often with a small central boss was a very popular motif during the early Islamic period, occurring on miniature jars and bottles, bowls and jugs. The solid rounded handle of this jug also has another characteristic feature of 9th and 10th-century production – a thumb-rest that rises up above the level of the rim. Originally this vessel would have been colourless but burial in the ground has given it a more cloudy appearance with a purple iridescence.

Height 12.4 cm
EA 1976.128. Gift of Mr James Bomford. Bought by him at Sotheby's, 13 July 1970, lot 306

Bibliography:
Unpublished, but for other early Islamic cut-glass vessels cf. K. von Folsach, *Islamic Art. The David Collection* (Copenhagen 1990), pp. 140–3 and J.Kröger 1995, pp.120–75

[1] Cf. D. Buckton (ed.), *The Treasury of San Marco, Venice*, exh. cat. (Milan 1984).

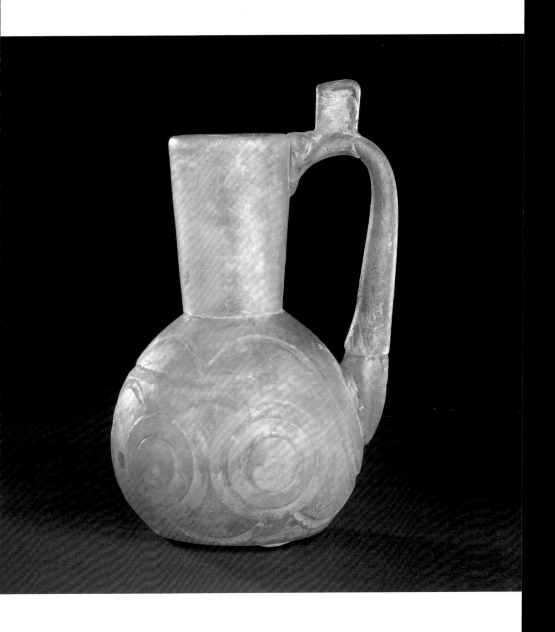

27– Islamic mould-blown flasks
28 Iran, 11th to 12th century AD

Islamic glass was not only wheel-cut but decorated while still hot, either through blowing the molten glass into a mould as on these two flasks, or with applied trailing that could be manipulated in a variety of designs. The trails could also be marvered flush with the body or left in relief as with the trailing on the lower part of the necks of both these flasks. While the clear glass flask bears a simple geometric design, the smaller flask in blue glass has a moulded Kufic inscription of good wishes sandwiched between arabesques above and a Z-pattern below. The moulds used to pattern the bodies of these flasks were probably made of metal and allowed for multiple copies to be produced. To make the design less sharp the glass was further inflated and expanded afterwards.

27. Colourless glass flask with a geometric design.
Height 24.5 cm
EA 1967.124. Purchased from the dealer, Mr Momtaz

28. Blue glass flask with a moulded inscription and an applied thin yellow spiral trail.
Height 19 cm
EA 1976.133. Gift of Mr James Bomford. Bought by him at Sotheby's, 13 July, 1970, lot 304

Bibliography:
For another 11th-century flask with a moulded inscription in the Victoria and Albert Museum, cf. R.Liefkes 1997, p. 28, fig. 26

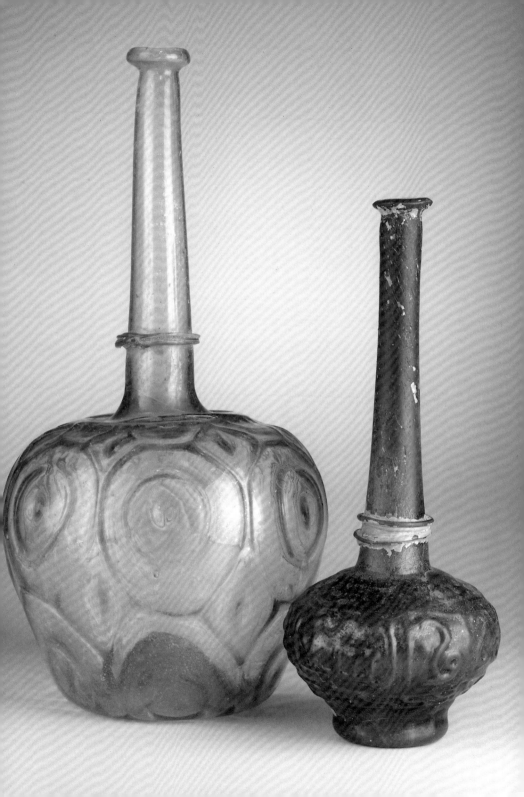

29– **Fatimid or early Mamluk bowl and footed cup**
30 Egypt or Syria, 12th to 13th century

Combed decoration in a contrasting colour was common on Syrian and Egyptian glasses dating from the late Fatimid and early Mamluk periods. These dark purple examples, coloured through the addition of manganese oxide to the batch, have been decorated with applied and marvered opaque white trailing. In the case of the small bowl the ribs were formed after the white spiral trailing was applied to create a wavy effect, while the trails on the goblet were combed or dragged up and down to create a feather pattern. Islamic glass was exported to Europe and a similar large ribbed basin with white trailing and a band of thick opaque turquoise trailing was found in 1855 during excavations in the Italian city of Padua.

29. Purple bowl with opaque white trailing and twenty-three ribs extending to the underside of the base. Rudimentary handle applied over the trailing to one side.
Height 7.5 cm; rim diameter 13.1 cm
EA 1975.18. Purchased from Mr James Bomford with the help of the Friends of the Ashmolean

30. Very bubbly dark purple glass footed cup decorated with opaque white trailing combed into a feather pattern.
Height 8.5 cm; rim diameter 7.1 cm
EA 1975.19. Provenance as for no. 28

Bibliography:
G. McKinley, *Ancient Glass and Glazed Wares* (London 1974), inside back cover; *Annual Report* 1974–1975, p. 49, pl. XI; Arts Council, *The Arts of Islam*, exh. cat. (London 1976), no. 144

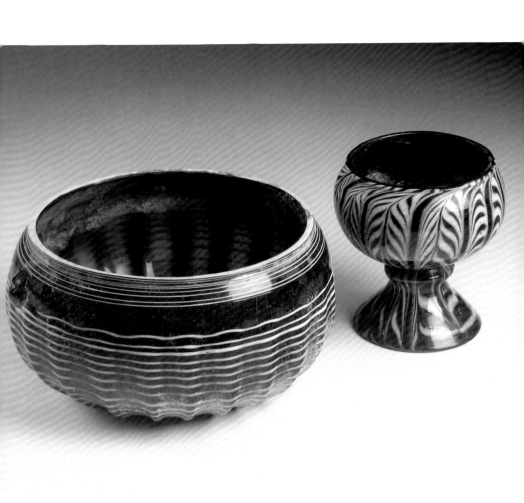

31 Gilt and enamelled mosque lamp
Syria, possibly Damascus, early 14th century

Mosque lamps are probably the best-known type of gilt and enamelled Islamic glass. They were made to adorn the principal mosques and religious buildings of Egypt and Syria and are usually decorated with part of a famous verse from the Koran in elaborate Kufic script that illustrates the importance of both light and lamps:

> Allah is the Light of the Heavens and the Earth
> The likeness of this Light is as a niche, in which is a lamp
> The Lamp is a glass, the glass as it were a shining star

Some examples also include the patron's name as on this lamp which is inscribed with the name of Sultan Muhammad ibn Qala'un (1294–1340).

Gilt and enamelled decoration on glass is reminiscent of that found on contemporary inlaid metalware like candlesticks and deep basins. They were first decorated in gilt and then the motif was outlined with a thin red line before being infilled with coloured enamels. However, when examined closely it is possible to see that it is not as well made or as finely decorated as it might first appear: the glass contains a lot of bubbles and pieces of grit and the whole form is slightly uneven, none of which would have mattered while it was hanging high up in the mosque suspended by metal chains attached to the three thick handles. The Syrian glasshouses where this type of glassware was produced were destroyed by Timur around 1400. This destruction also coincided with the rise of Venice as the most important glass-making centre in Europe and by the mid-16th century Venice was exporting mosque lamps to Syria.

Height 31 cm
EA 1972.5. Purchased with the aid of the Friends of the Ashmolean

Bibliography:
Annual Report 1971–1972, p. 48, pl. XIX

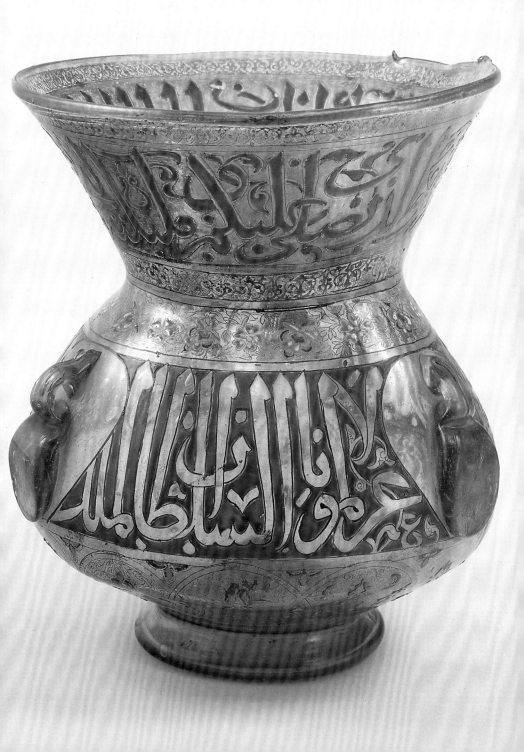

32 Islamic gilded blue glass jug
Syria, first half 14th century

In addition to mosque lamps, a wide variety of other shapes were decorated in gilt and enamel during the 13th and 14th centuries in the Middle East. These include a small group of vessels made in coloured glass, usually transparent dark blue or purple, and occasionally in opaque white or turquoise. This rare, and possibly unique, blue glass jug, was decorated only in gilt. The gilding has since disappeared and now only survives as a shadow. Apart from five horizontal bands it is also possible to see traces of a *naskh* inscription on the neck and another around the widest part of the body. The inscriptions are eulogistic and contain the name and titles of the Sultan al-Manṣūr Ṣalāḥ al-dīn Muḥammad, who ruled from 1361 to 1363. Between the two inscriptions are alternating lobed arched arabesques and four lobed circle motifs which have parallels with designs on other coloured pieces.

This jug was probably made in Syria. Damascus, especially, was renowned for producing highly decorated glass during the 13th and 14th centuries. Enamelled glass from Damascus was highly prized in medieval Europe, appearing in the inventories of kings and nobles and surviving in church treasuries like St Stephen's, Vienna.

Height 11.5 cm; rim diameter 5.4 cm
EA 1977.9. Purchased with the aid of the Friends of the Ashmolean

Bibliography:
Annual Report (1976–1977), p. 57, pl. XVI; M.S.Newby, 'The Cavour Vase and gilt and enamelled Mamluk coloured glass', in R.Ward (ed. 1998), p. 38, no. 2, figs 10.12 and 10.13

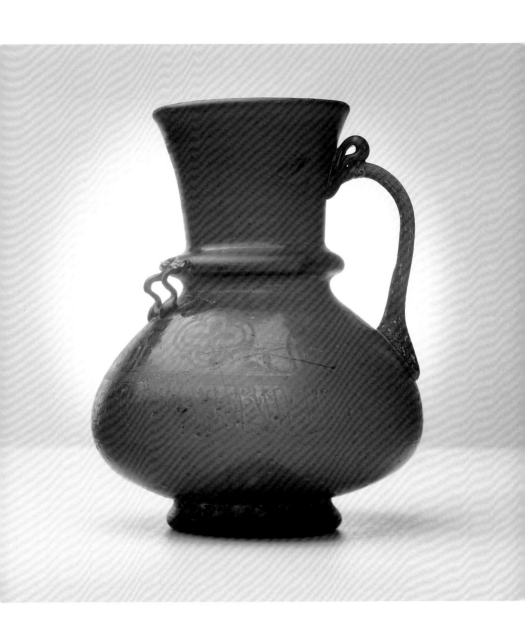

33 Gilt and enamelled ewer
Venice (Murano), early 16th century

During the Renaissance, Venetian glass was highly prized throughout Europe and became one of Venice's most celebrated exports. The industry was highly organised in a guild, whose first set of rules and regulations, the *Capitolare*, dates from 1271. Twenty years later a decree stipulated that all new glass-houses could only be established on the Island of Murano. This was for reasons of fire-safety as well as a means of enforcing tighter controls over the industry.

In the mid-15th century Angelo Barovier, a member of an important Muranese glass-making family, is credited with the introduction of a new type of very clear and pure glass. It was called *cristallo* after its resemblance to rock crystal, although it could also be made in rich gem-like colours. Many pieces such as goblets, beakers, jugs and footed salvers were further embellished with gilt and enamelled decoration, influenced by earlier Islamic pieces (cf. no. 31). This could take the form of a simple incised gilt band with enamelled 'jewels' below the rim, armorials of noble families and even popes, or designs derived from classical motifs such as the scrolled foliage on this jug (whose handle is missing). Here blue, yellow, red, green and white enamel has been applied partly over gold-leaf, a constant feature in Venetian Renaissance glass. On later 19th-century reproductions and forgeries, however, the gilt is often applied over the enamels.

Height 22 cm
WA 1899 CDEF.G86. Bequeathed by C.D.E.Fortnum; given to him by Mr John Holland

Bibliography:
For a similar jug in the Louvre, Paris, and examples in blue glass in the Victoria and Albert Museum, London, and the Metropolitan Museum of Art, New York, cf. Lanmon 1993, pp. 16–20, no. 3

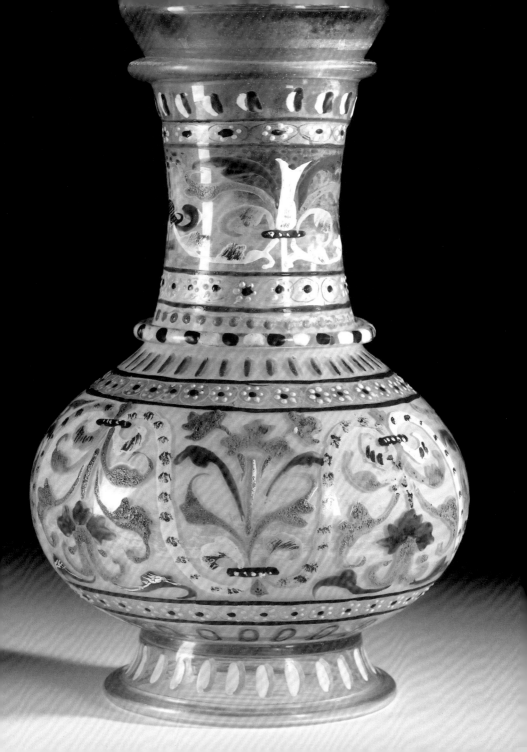

34 Diamond-engraved plate
Venice (Murano), mid-16th century

During the later 15th century and the first half of the 16th century Venetian *cristallo* glass was decorated with coloured enamels (cf. no. 33) or engraved with the point of a diamond. This plate shows how delicate this diamond-point engraving could be. The upperside of the plate is decorated with three concentric bands of fired gold-leaf, the overlapping edges can clearly be seen, and three bands of diamond-point engraving that include papal devices such as the crossed keys of St Peter and the *ombrellino* (or heraldic pavilion) as well as grotesque masks, dolphins, swags and birds. These sections are separated by six *lattimo* or opaque white threads applied on the underside of the plate. This plate belongs to a group of twelve extant plates and a goblet from a Papal service, three examples of which are further embellished with the arms of the Medici Pope Pius IV (1559–1566) in the centre.

Rim diameter 26 cm
WA 1899.CDEF.G75. Bequeathed by C.D.E.Fortnum. Formerly in the collection of Charles Sackville Bale (Christie Manson and Woods, 25 May 1881, lot 1553, £1.6s.)

Bibliography:
A.E.Engels-de-Lange and A.J.Engels, 'A goblet and twelve plates from the mid-16th century', *Annales de l'Association Internationale pour l'Histoire du Verre* 13 (1996), pp. 381–8

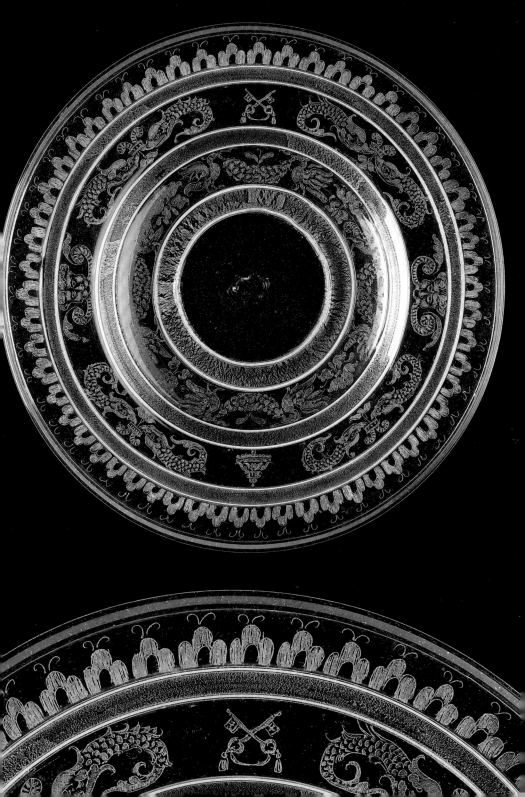

35 Ruby glass beaker with silver-gilt mounts

The glass was made in southern Germany, but engraved in Nuremberg, probably by Heinrich Schwanhardt, *c.* 1690

In 1679 Johann Kunckel (1639–1703), a gifted alchemist and arcanist who worked for the Elector of Brandenburg as manager of the Potsdam factory, published his treatise on glass-making, *Ars vitraria experimentalis.* Among his recipes was one for a type of glass with a deep ruby tint, known as gold-ruby glass, because a precipitate of gold (a gold chloride) was added to the batch.

This beaker belongs to a group of gold-ruby glasses, attributed to the wheel-engraver Heinrich Schwanhardt, which were decorated with allegories of love and French inscriptions. The designs were taken from an anonymous book of emblems published by Daniel de la Peuille in 1691 in Amsterdam, *Devises et Emblèmes Anciennes & Modernes.* On this beaker Cupid is depicted seated on a rock with a quiver and arrows, looking towards a sunflower and pointing upwards to a sun in splendour. On the reverse is a calligraphic inscription, *'Mon regart* [sic] *vers le soleil'* (I look towards the sun). The underside of the base is cut with a sunflower surrounded by leaves. The silver-gilt mounts bear the mark for Nuremberg and a six-petalled rosette probably the mark of Wolfgang Rössler, master of the Goldsmiths' Guild (d. 1703).

Height 10.8 cm
WA 1899.CDEF.G78. Bequeathed by C.D.E.Fortnum. Formerly in the Charles Sackville Bale Collection (Christie Manson and Woods, 25 May 1881, lot 1568, £5)

Bibliography:
Other pieces engraved by this hand include a tankard in the Wolf Collection, Stuttgart (Klesse and Mayr 1987, no. 78) and a beaker formerly in the Biemann Collection (B.Klesse and A.von Saldern, *500 Jahre Glaskunst,* Zurich 1978, pp. 37–8, no. 99)

Calligraphic inscription on the reverse of the beaker

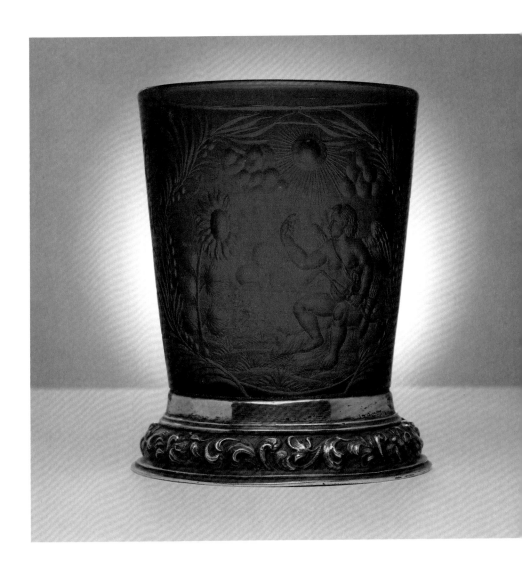

36 Gilt and engraved covered glass goblet
Potsdam, Germany, c. 1730–1735

The glass factory at Potsdam (west of Berlin) was founded by the Elector Friedrich Wilhelm of Brandenburg in 1679, before moving to Zechlin in 1736 where it remained under state control until 1890. The glass produced at this and other factories in northern and central Europe was much thicker and more suitable for wheel-cut engraving than Venetian or *façon de Venise* glass. The technique of wheel-engraving was developed from the tradition of cutting hard stones and especially rock crystal.

This covered goblet belongs to a small group of glasses cut and gilded with portraits of members of the Prussian royal family. The profile bust to the right within a circular medallion surmounted by an eagle below a crown, with two eagle supporters to the sides and crossed cornucopiae below, is of Sophia Dorothea (1685–1757), Queen of Prussia and daughter of George I of England. Originally it would have been one of a pair, the other goblet having a portrait bust of her husband, King Friedrich Wilhem I of Prussia (ruled 1713–1740). Similar ceremonial or presentation goblets were always made with covers, the finials of which echo the formation of the stem.

Height 40 cm
WA 1899.CDEF.G50. Bequeathed by C.D.E.Fortnum. Probably bought from the Francis Forbes collection (Christie Manson and Woods, 25 March 1874, lot 51, £3.8s.)

Bibliography:
For comparable examples in the Wolf and von Strasser collections cf. Klesse and Mayr 1987, no. 134 and von Strasser and Spiegl 1989, pp. 280–1, no. 145 respectively

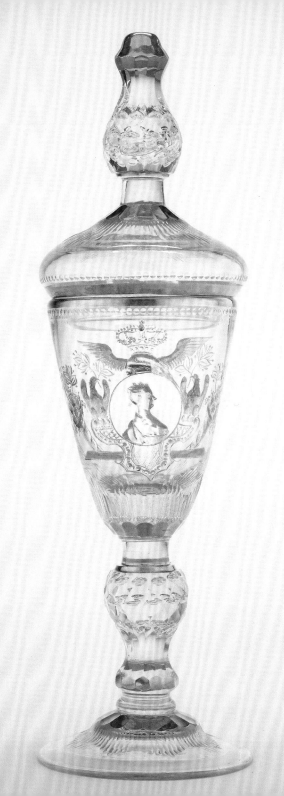

37– Two sealed wine-bottles
38 Oxford, England, one mid-17th century, the other dated 1715

Green glass wine-bottles like these were used for carrying wine from the cask to the table in the period before wine was laid down in cylindrical bottles. These two examples have moulded seals which identify them as having belonged to the Three Tuns Tavern in Oxford. The shaft and globe example on the left dates to the mid-17th century when the tenant from 1639 to 1660 was a Humphrey Bodicott, identified by the initials H.B. (see below left). The onion-shaped bottle on the right has a dated seal of 1715 with the initials A.T. (see below right) for the then landlady, Anne Tomlinson (1712–1719). In the 18th century large number of bottles were used for carrying wine to the colleges in Oxford. The seals on these bottles bear the initials of the college and often have the additional letters, C.R. (Common Room). Sealed bottles for wealthy private individuals, many of whom were Members of Parliament, can have crests, armorials and even place-names.

37. Shaft and globe bottle, the seal with H.B. on either side of a vintner's bush and below, three tuns.
Height 22 cm
AN 1874.44. Found with other sealed bottles, a jug and a cup, in making King Edward Street, High Street, Oxford

38. Onion-shaped bottle, the seal with the initials A.T. above the arms of the Vintners' Company, a chevron between three tuns; on either side a formal spray and below, the date, 1715.
Height 14 cm
AN 1896.1908. Presented by the Oxford Architectural and Historical Society

Bibliography:
E.T.Leeds, '17th and 18th century wine-bottles of Oxford taverns', *Oxoniensia* 6 (1941), pp. 44–55, pls IX–X, nos. 23 and 34; F.Banks, *Wine Drinking in Oxford, 1640–1850: a Study Revealed by Tavern, Inn, College and Other Bottles* (Oxford 1997), pp. 42–9, figs 5.7 and 5.12

Detail of seal on no. 37 Detail of seal on no. 38

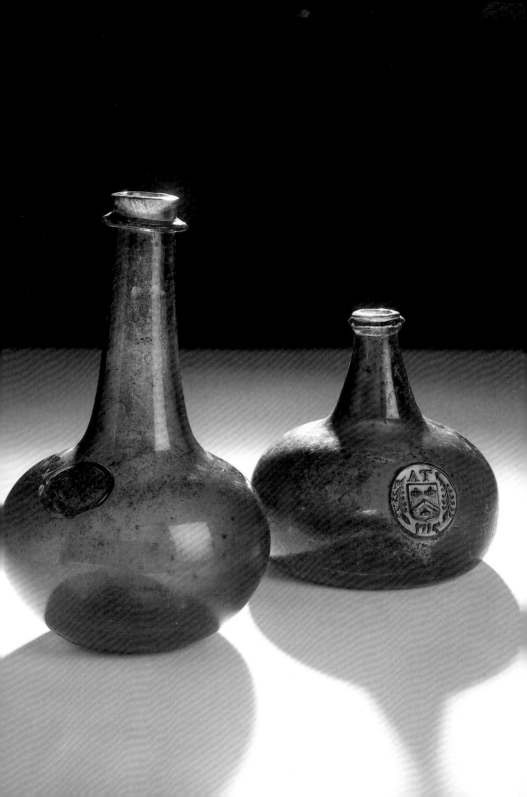

39 Purple decanter-bottle
Anglo-Dutch, possibly by George Ravenscroft,
c. 1680

During the 1670s experimentations by English and Dutch glass-makers led to the development of a new type of glass made from calcined pebbles that also contained a high percentage of lead. This so-called 'lead-glass' or 'crystal' was much heavier, less fragile and more brilliant than that produced previously in either England or Europe. In 1674 George Ravenscroft (1618–1681) a glass merchant who belonged to the Worshipful Company of Glass Sellers, obtained the first patent for the production of lead-glass in England. His early pieces suffered badly from crizzling, a fine network of cracks that gave the glass a cloudy appearance, caused by a chemical imbalance in the glass. Three years later, in 1677, believing that this fault had been remedied he began to mark his glass with an applied raven's head seal. Many of these marked pieces, however, are now also crizzled.

The glass of this amethyst-tinted serving bottle with a tall wrythen neck contains traces of lead. The pincered decoration of lozenges on the bulbous body then known as 'nipt diamond waies' has Venetian origins. This is not surprising as workers from Murano were employed in Ravenscroft's glass-house at the Savoy, London. Yet while a comparable but lightly crizzled bottle in the Victoria and Albert Museum has been attributed to the workshop of George Ravenscroft, similar examples found on the other side of the English Channel have been assigned North-western European origins.[1]

Height 19 cm; max. diameter 12.6 cm
WA 1957.24.2.1. Gift of Mrs M.Marshall. Bought in Perth from Mr Cutchen on 8 August, 1939, for five shillings

Bibliography:
GL.Taylor 1977, front and inside cover; M.S.Newby 1999, p. 29, no. 3, fig. 5 on p. 27. For a recent study on early lead-glass cf. P.Francis, 'The development of lead glass. The European connection', *Apollo*, vol. CLI, no. 456 (February 2000), pp. 47–53

[1] Cf. R.J.Charleston 1984, pl. 25d and P.C.Ritsema van Eck and H.M.Zijlstra-Zweens 1993, pp. 188–9, no. 299 respectively.

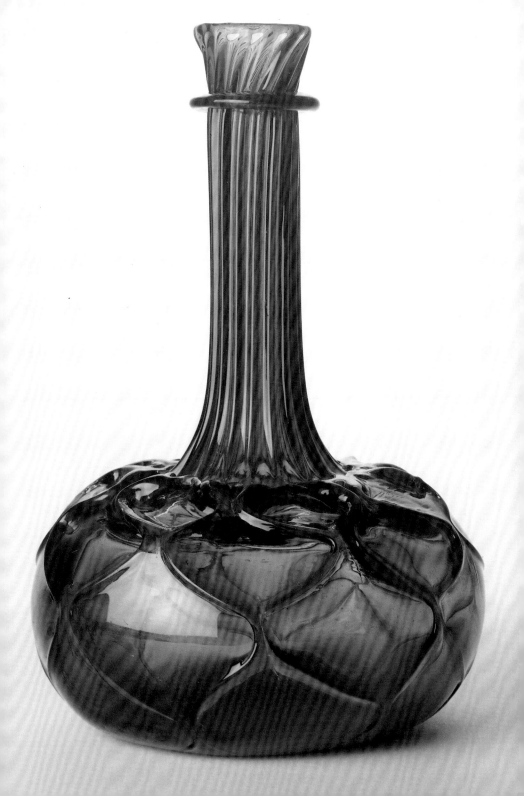

40 Diamond-engraved baluster goblet
English, *c.* 1710–1720

This large lead-glass goblet with a round funnel bowl set on an inverted baluster stem and a folded conical foot is typical of the large and simple forms produced in the first quarter of the 18th century. The bowl, however, is more unusually engraved in diamond-point with a naive Fall of Adam and Eve. They are depicted standing naked except for leafy garlands to either side of the Tree of Knowledge, its branches laden with apples and the serpent entwined around its trunk. The rest of the bowl is filled with the beasts of the field and birds of the air arranged roughly into three tiers and not to scale. The animals include rabbits, a lion, stag and doe, elephant, fox, peacock, pheasant and doves (see detail below). The subject matter of this engraving may also be found on contemporary Bristol Delft and on stumpwork.

Height 27 cm; rim diameter 13.4 cm
WA 1957.24.2.21. Gift of Mrs M.Marshall. Purchased on 27 June, 1950, for £85, from a Bristol dealer, Mr Elson, who had reputedly acquired it from a local family

Bibliography:
G.L.Taylor, *English Drinking Glasses in the Ashmolean Museum, Oxford* (Oxford 1977), pp. 6–7; M.S.Newby 1999, p. 29, no. 5, fig. 7 on p. 28 and front cover. For a similarly engraved goblet with a moulded pedestal stem cf. W.A.Thorpe, *A History of English and Irish Glass* (London 1924), pl. CI

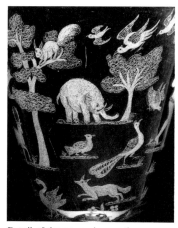

Detail of the engraving on the reverse of the bowl

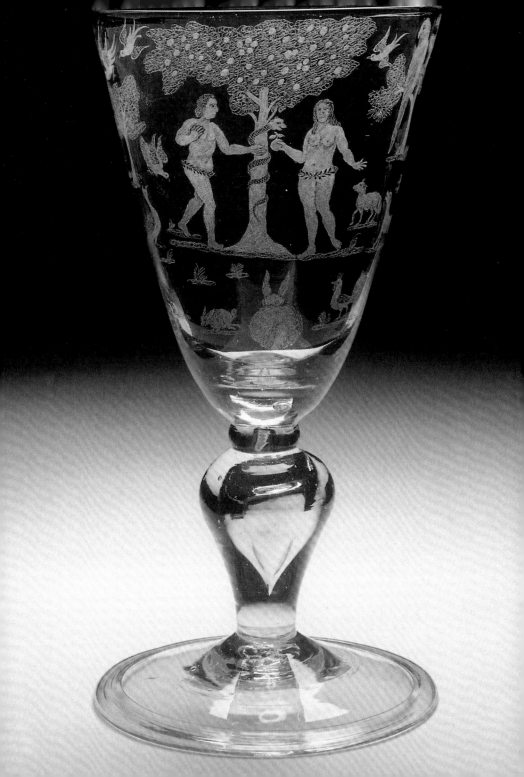

41 Punch bowl

English, engraved by the 'Calligraphic Master',
dated 1732

Lead-glass punch bowl with a wide hemispherical bowl
set on a folded pedestal foot. Below the rim is a dated
inscription engraved in diamond-point, 'John Morley
Arundell: 1732' with S scrolls below. It is possible that
John Morley was the fourth and last Baron Arundell of
Treice, Cornwall, who succeeded to the title and died in
1768. The reverse is engraved with a Latin couplet,

Combibones Zythi Sileant miranda vetusti;
Nauticus hic potus plura Stupenda facit

(Let drinking companions keep silence concerning the
marvels of the ancient brew [zythum – a kind of malt
liquor]: this seaman's tipple works more wonders).
Between the inscriptions are two small panels each con-
taining a bird, scrolling, flowers and leaves. Robert
Charleston identified thirteen glasses engraved by this
hand, whom he called the 'Calligraphic Master' and
tentatively identified as a Jacobite schoolmaster from
the West Country.

Height 13.1 cm; rim diameter 23 cm
WA 1948.156.96. Bequeathed by Sir Bernard Eckstein

Bibliography:
R.J. Charleston, 'Some English glasses with diamond-point decora-
tion: the Calligraphic Master', *The Burlington Magazine* 136, no.
1094 (May 1994), pp. 276–82

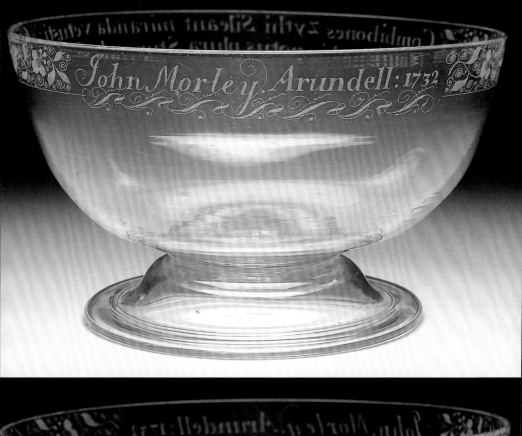

John Morley . Arundell : 1732

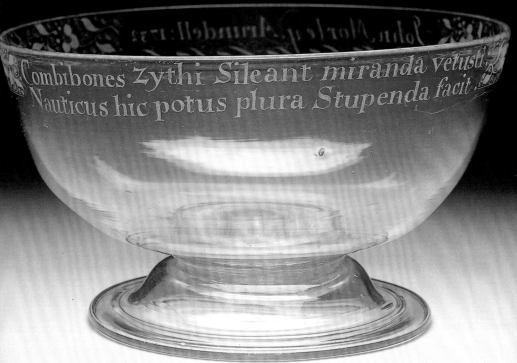

Combibones Zythi Sileant miranda vetusti
Nauticus hic potus plura Stupenda facit .

42– Two commemorative wineglasses
43 English, c. 1740–1750

These two drawn trumpet wineglasses of identical form and manufacture commemorate both sides of the great political divide in 18th-century England: the Williamites and the Jacobites. The glass on the left is wheel-engraved with a profile bust of William Augustus, Duke of Cumberland (1721–1765) below the legend, 'Prosperity to the Duke of Cumberland'. Victorious at the Battle of Culloden on 16th April, 1745, 'Butcher' Cumberland finally ended the Jacobite cause led by the Young Pretender, Prince Charles Edward, better known as Bonnie Prince Charlie. Jacobite and Williamite glass was so highly prized by glass collectors at the beginning of the 20th century that it is now believed that some examples may be fakes with modern engraving on period glasses.[1]

The other glass is the Fisher of Ham Common Amen glass named after its first recorded owner, Mrs Fisher of Ham Common, Richmond, Surrey. Both the bowl and the foot of this wineglass are engraved in diamond point with four verses from the Jacobite Anthem. The front of the bowl is further engraved with a crown and JR cipher with intertwined 8s (for James VIII of Scotland) above the word, 'AMEN'. On either side are two toasts, 'To His Royal Highness the Duke' and 'To the Increase of the Royal Family'.

42. Duke of Cumberland wineglass
Height 16.4 cm; rim diameter 7.6cm
WA 1948.156.68. Bequeathed by Sir Bernard Eckstein

43. Fisher of Ham Common Amen glass
Height 18 cm; rim diameter 8.9 cm
WA 1948.156.64. Bequeathed by Sir Bernard Eckstein

Bibliography:
R.J.Charleston and G.Seddon, 'The "Amen" glasses', *The Glass Circle Journal* 5 (1986), pp. 4–20, no. 5; G.Seddon, *The Jacobites and Their Drinking Glasses* (Woodbridge 1995)

Detail of engraving on the side of the Amen glass (no. 43)

[1] For a discussion of a group of 'Williamite' glasses engraved by the Bohemian artist, Franz Tieze cf. Peter Francis 'Franz Tieze (1842–1932) and the re-invention of history on glass', *The Burlington Magazine* (May 1994), no. 1094, Vol. CXXXVI, pp. 291–302

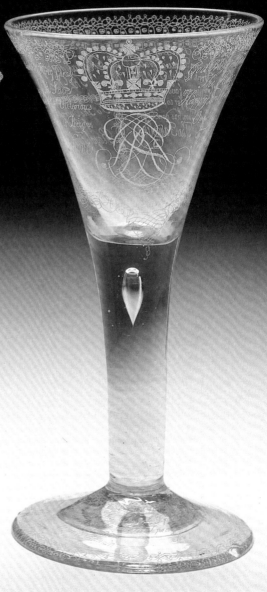

44– Three Beilby enamelled glasses
46 Newcastle, England, c. 1770, the bottle dated 1769

William Beilby (1740–1819), the son of a silversmith and jeweller in Durham, learned enamelling and painting while apprenticed to John Haseldine, a drawing master and enameller in Birmingham. At the end of the 1750s the family moved to Newcastle where William, together with his sister Mary and other members of the family, enamelled glasses with rural vignettes (no. 45), classical scenes (no. 46) or bands of fruiting vine, until 1778 or 1779. They mostly decorated opaque-twist wineglasses typical of the period, but also worked on decanters, sugar bowls, tumblers, punch bowls and large goblets, some of which have polychrome decoration. The bottle on the left with the dated inscription, 'Tho[s] Brown Nenthead 1769' has a huntsman shooting at a flock of birds on the reverse (see below). Nenthead was a lead-mining village on Alston Moor, Cumbria, about 50 miles west of Newcastle, where Thomas Brown was the local mine owner. It is possible that Nenthead was a source of lead for the glass-making industry in Newcastle.

44. Flattened flask inscribed 'Tho[s] Brown, Nenthead 1769'.
Height 21 cm
WA 1957.24.2.181. Gift of Mrs M.Marshall. Purchased from the London dealer, Derek Davis, 13 June, 1956, for £3.15s.

45. Opaque twist wineglass, the round funnel bowl decorated with a pastoral vignette containing two sheep.
Height 15.3 cm; rim diameter 5.4 cm
WA 1948.156.48. Bequeathed by Sir Bernard Eckstein

46. Opaque-twist wineglass, the ogee bowl decorated in white enamel with a classical stone pyramid in a landscape.
Height 15 cm; rim diameter 5.4 cm
WA 1948.156.45. Bequeathed by Sir Bernard Eckstein

Bibliography:
J.Rush, A Beilby Odyssey (Olney 1987), fig. 29 on p. 69

Reverse of the bottle (no. 44) showing a huntsman shooting at a flock of birds

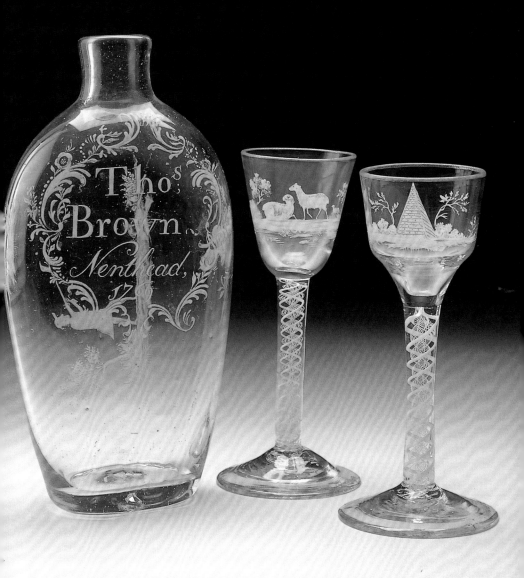

47– Two Nécessaires
48 London, the boxes made by Paul Barbot, the glass bottles and cases gilded in the atelier of James Giles, c. 1765–1770

These two boxes are nécessaires filled with toilet articles including nail clippers, spoons, folding knives, pencils and gilded glass scent bottles and mirror cases decorated in the atelier of James Giles (1718–80). Giles was a noted independent London decorator of enamelled porcelain who also gilded and painted with enamel on glass.[1] The glass scent bottles, cruets and vases he obtained from the Flacon Glassworks and the Parker Cut Glass Manufactory in London were usually opaque white (made in imitation of porcelain) or coloured (generally green or blue as with these examples). The more common designs he used included exotic birds, pheasants, neo-classical motifs and flowers.

The nécessaire on the right (no. 48) has a concealed signature in pencil, '1769, Barbot, London'. This would appear to be the signature of Paul Barbot, the son of John Barbot, a Huguenot goldsmith, who entered a smallworker's mark at Goldsmiths' Hall on 22 July 1726. In 1765 Paul was taken into partnership by his father at the sign of the Golden Lion, Great St Andrews St, Seven Dials. John died the following year but Paul continued the business and initially produced pieces which are indistinguishable from those of his father although he had adopted the neo-classical style by 1774–75. The firm acted as outworkers for the goldsmiths Parker and Wakelin from the late 1760s.

47. Agate and copper nécessaire with pierced cage-work of floral sprays, birds and a dog, containing toilet articles, a mirror and two blue bottles gilded with rural figures in the atelier of James Giles. Height 5.5cm; width 5.2 cm; height of blue glass bottle 4.2 cm
WA 1957.111.42. Presented by Mrs J.M.Hanbury through the National Art Collections Fund in memory of her son, John MacKenzie Hanbury

48. Signed agate and copper nécessaire on shell feet, with pierced gold rococo cagework and an inscription, 'RIEN NEST TROP BON POUR CE QU'ON AIME' (Nothing is too good for the beloved). Height (inclu. finial) 11.5 cm; width of body (exclu. feet) 5.7 cm
WA 1957.111.45. Provenance as for no. 47

Bibliography:
Annual Report 1957, p. 48

[1] Cf. R.J.Charleston, 'James Giles as a decorator of glass', *The Connoisseur* (June 1966), p. 96 and (July 1966), p. 176.

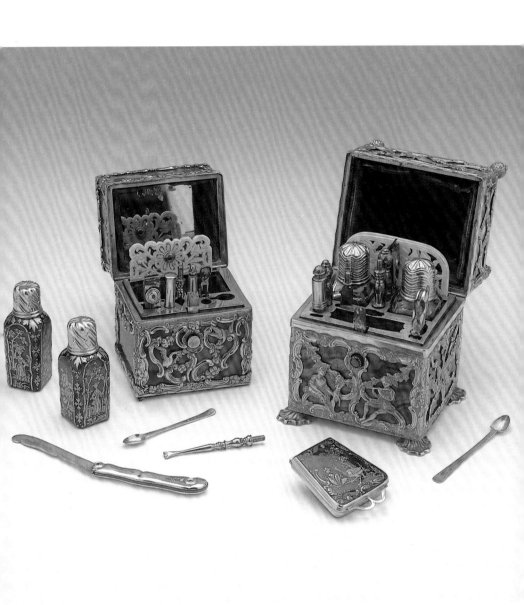

49 Pair of stipple-engraved goblets by David Wolff
The glass English, the engraving Dutch, *c.* 1790

Stipple-engraving involved the tapping of the surface of the glass with a sharp point, usually a diamond, to make a small dot and create a light and shade effect – the greater the density of dots the lighter the decoration. This technique was first developed by Frans Greenwood (1680–1761), who worked in Dordrecht, Holland. He, in turn, influenced a number of other engravers including Aert Schouman (1710–1792), David Wolff (1732–1798) and Jacobus van den Blijk (1736–1814). Their work also inspired the modern engraver Laurence Whistler (see no. 56).

These two glasses were stipple-engraved by David Wolff, on English facet-stemmed glasses, with portrait busts of Prince Willem V of Orange on the left and his wife, Princess Frederica Sophia Wilhelmina of Orange and Nassau on the right. Each is identified by an inscribed banderole. Wolff started as a line-engraver, gradually adding stippling to his work. He was a commercial engraver, decorating glasses with portraits, armorials, commemorative and rococo allegorical scenes especially of friendship and freedom.

Height 17.2 and 17.4 cm
WA 1957.24.2.393a,b. Gift of Mrs M.Marshall. Bought through the London dealer, Cecil Davis, from Sotheby's, 28 July 1949, lot 85, for £160

Bibliography:
Glass Circle, *Commemorative Exhibition 1937–1962*, Victoria and Albert Museum (London 1962), p. 59, no. 310; F.G.A.M.Smit, *Uniquely Dutch Eighteenth-Century Stipple-Engravings on Glass* (Peterborough 1993), p. 89, no. Cd 39 and p. 188, no. Da 4

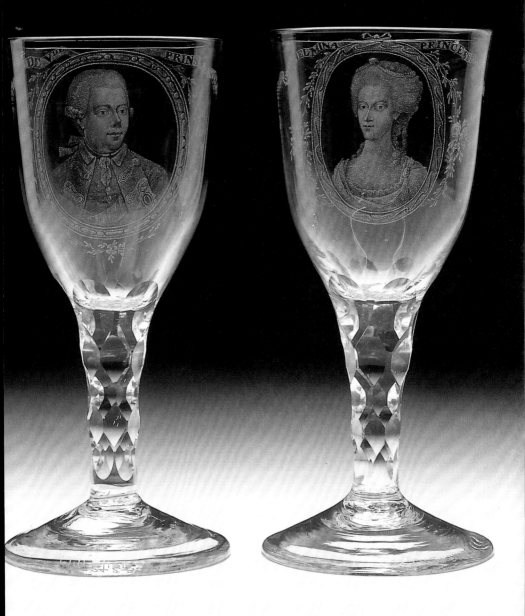

50 *Lattimo* plate with a Venetian scene
Venice (Murano), *c.* 1741, probably made in the glass-house of Vincenzo Miotti

This opaque white (*lattimo*) glass plate, which might at first sight be taken for porcelain, is not run-of-the-mill Venetian production. It is painted with the Church of SS. Giovanni e Paolo, Verrocchio's equestrian monument to Colleoni, and gondolas. Three sets of such *lattimo* plates with Venetian scenes were made on special commission for three English 'Grand Tourists' who were in Venice together in 1741 – one set for Horace Walpole (1717–1797); another for his friend John Chute (1701–1776) of the Vyne, Hampshire; and the third for Henry Fiennes Clinton (1720–1794), Ninth Earl of Lincoln and later Second Duke of Newcastle; the present plate is one of the this last set.

The subject is taken from an engraving by Antonio Visentini after a painting by Canaletto (see below). The improbable widening of the canal on the plate is an expedient to fill the circular form of the plate. The engraving was published with a title-page dated 1742, and it was convincingly argued by Robert Charleston that the availability of this as-yet-unpublished source to the anonymous glass-painter was due to the intervention of Joseph 'Consul' Smith, the focal point for British aristocratic visitors to Venice.

Diameter 22.7 cm
WA 1997.25. Presented by the National Art Collections Fund in memory of Robert Charleston (1916–1994), Keeper of Ceramics and Glass in the Victoria and Albert Museum and Member of the Advisory Council of the Fund

Bibliography:
R.J.Charleston, 'Souvenirs of the Grand Tour', *Journal of Glass Studies* 1 (1959), pp. 63–82; T.Wilson, 'A Grand Tour souvenir of Venice', *The Ashmolean* 33 (Christmas 1997), pp. 12–13

Engraving of the Piazza SS. Giovanni e Paolo, Venice, by Visentini, published in 1742. 27.5 x 42 cm. Presented by Mrs F.E.Maitland and Mrs M.J.Meeres. WA 1976.24

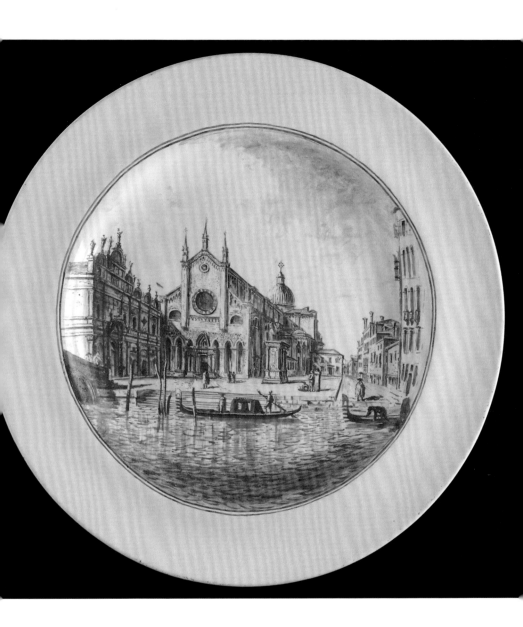

51 Pair of cameo vases
China, Qianlong Dynasty, 1736–1795

Very few Chinese glass vessels can be dated before the establishment of an imperial glassworks as part of the Zaobanchu, or Palace Workshop, in Beijing in 1696, by the decree of the emperor Kangxi (1662–1722). This glass-house was probably set up with the aid of Europeans, especially the Dutch Jesuit Ferdinand Verbiest and a German priest, Kilian Stumpf. The Chinese treatment of glass, however, is very different to that practised in western Europe. They generally preferred other materials like jade, bronze and lacquer for making vessels so that glass was used like a type of stone to be carved using traditional lapidary techniques rather than a liquid to be blown into many different and delicate shapes. The shapes of Chinese glasses are very simple and strong, the walls are very thick suitable for wheel-cutting, facetting and engraving, and the rich gem-like colours have a waxy sheen. The most elaborate pieces produced were those composed of two or more coloured layers where the outer layer/s were cameo-cut leaving the design in relief against a background. The background is usually made of clear or 'snow-flake' glass like this pair of vases which have a rich transparent ruby-red overlay. The 'snow-flake' glass is so-called because of the tiny bubbles and white inclusions in the glass. These two vases with long cylindrical necks and bulbous bodies are cameo cut with carnations, trees, rock-work and birds.

Height 22 cm
EA 1997.39 and 1997.40. Gift of Anthony and Olive Hallam

Bibliography:
Annual Report 1996–1997, p. 48

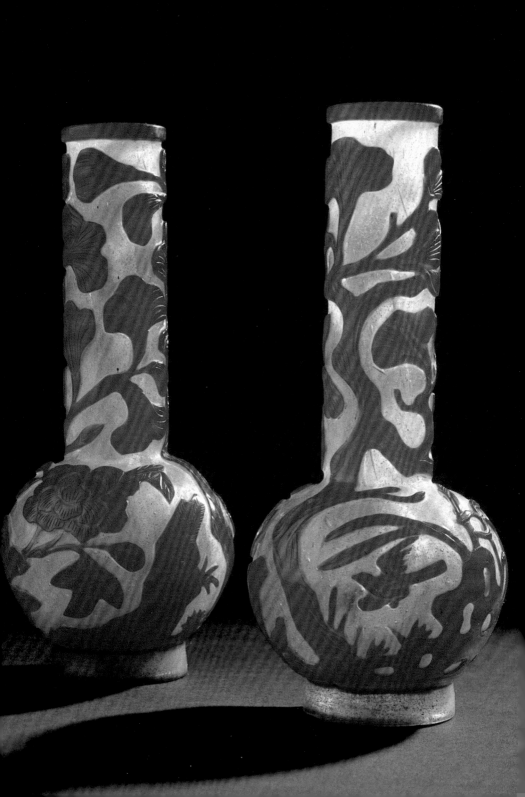

52–
53
Two Biedermeier beakers

Vienna, Austria, c. 1820–1830. The beaker with roses decorated by Anton Kothgasser

The technique of decorating glass in transparent enamels or *Transmalerei* was developed by Samuel Mohn (1762–1815) in the early part of the 19th century. Mohn, a porcelain painter, first began experimenting painting enamelled portraits on glass in Leipzig before moving to Dresden. His work was continued by his son, Gottrob (1789–1825) who moved to Vienna in 1811, where this type of decoration was taken up by Anton Kothgasser (1769–1851), a decorator at the Royal Vienna Porcelain Manufactory. In 1816 Kothgasser set up his own studio for decorating glass, producing beakers like the example on the left decorated with flowers and an inscription, 'Ehret die Frauen! Sie flechten und weben, himmlische Rosen ins irdische Leben' (Honour the women! They spin and weave heavenly roses into earthly life). He also decorated beakers with portraits, townscapes, allegorical scenes, birds and flowers.

The form of beaker on the right belongs to the neo-classical, so-called *Biedermeier* style of furniture produced in Austria from 1820 to 1840, which itself followed the Empire style in France. This beaker with a thick colourless body has a very thin coloured coating 'flashed' on the outside to give it an amber colour that was then further decorated with gilding.

52. *Transmalerei* and gilded beaker decorated by Anton Kothgasser with a panel of roses and pansies on a black ground and an inscription.
Height 9.7 cm; rim diameter 7.4 cm
WA 1939.46. Presented by Mrs Ida Boulter

53. Octagonal amber flashed and gilt waisted beaker with a light ruby flashed raised panel engraved with the crowned monogram 'FW' between a laurel and an olive leaf.
Height 10.7 cm; rim diameter 7.8 cm
WA 1939.45. Presented by Mrs Ida Boulter

Bibliography:
Annual Report 1939, p. 29. For an example with the same inscription in the Museum für Kunst und Gewerbe, Hamburg, cf. W. Spiegl, *Biedermeier-Gläser* (Munich 1981), fig. 185 on p. 162

54 Cameo glass vase
Venice, probably made by the Compagnia di
Venezia e Murano and engraved by Attilio
Spaccarelli, c. 1890

From the mid 19th century there was a revival of inter-
est in the works of art of earlier periods. The
Historismus pieces produced ranged from exact copies
to others with stylized decorative motifs based on
Venetian High Renaissance glass, German enamelled
and form glasses of the 16th and 17th century, gilt and
enamelled Islamic glass and ancient Roman glass, espe-
cially mosaic and cameo-cut pieces.

The first revival of cameo-cutting since ancient
Roman times took place in England and was especially
the achievement of John Northwood (1836–1902). This
dark brown banded glass vase, however, made in imita-
tion of agate with an opaque white overlay, is a much
rarer Venetian example. It is cameo cut with bands of
Greek ornament and four classical youths, probably
Bacchants, naked except for leopard skins. On the front
two youths, one with loosely bound hands, are treading
grapes in a large tub and on the reverse one is playing
the Pan-pipes and the other holds a woven basket filled
with fruit. Similar revival pieces have classical themes,
like Dionysiac scenes with satyrs, maenads and dancing
women. A similar band of ivy leaves occurs on a small
cup in the Museo Vetrario, Murano, that is signed 'VM'
for the Compagnia di Venezia e Murano.

Height 15 cm; rim diameter 9.1 cm
WA 1947.191.297. Bequeathed by J. Francis Mallett

Bibliography:
For further discussion on Venetian cameo glass cf. R.Barovier,
'Roman glassware in the Museum of Murano and the Muranese
revival of the 19th century', *Journal of Glass Studies* 16 (1974), pp.
111–19; S.M.Goldstein, L.S.Rakow and J.K.Rakow, *Cameo Glass.
Masterpieces from 2000 Years of Glassmaking*, exh. cat. (Corning
1982), pp. 15–17

Reverse side

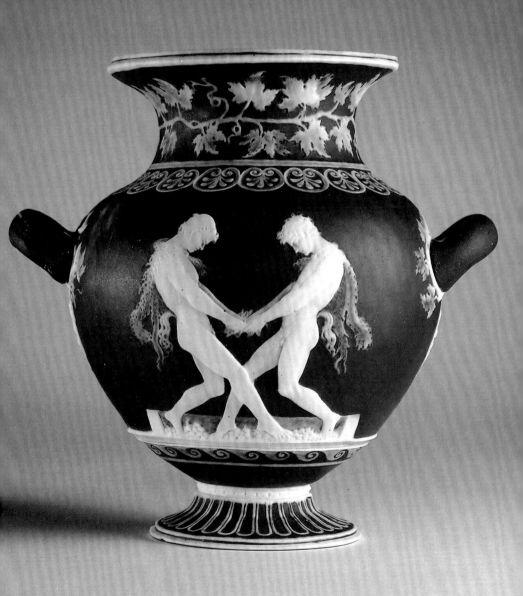

55 'Gourds' vase
René Lalique, France, 1914–1947

At the end of the 19th century a new, international style of decoration known as Art Nouveau was developed in France and Belgium, peaking at the turn of the century. This style, known as *Jugendstil* in Germany, was inspired by nature and emphasized the curvilinear shapes of plants and especially stems and tendrils. This globular vase of organic form is decorated with a moulded pattern of gourds with long and curled tendrils was inspired by this movement although it was conceived by one of the most famous Art Deco designers, René Lalique (1860–1945). The design for the vase dates from 1914 and it remained in production for thirty-three years. It was manufactured by pressing the hot glass mechanically into a patterned mould (no. 1005), which enabled multiple copies to be made. There is also a faint 'LALIQUE' mark impressed on the underside of the bottom.

René Lalique, whose earlier career was dominated by the designing of expensive pieces of jewellery with enamelled decoration, first made one-off pieces of glass using the lost wax process. He began mass-producing glass scent-bottles in the 1910s for the *parfumier* François Coty and then expanded to design a wide range of bowls and vases as well as decorative objects ranging from ash-trays to car mascots. Generally his pieces show neo-classical influences or Art Deco geometric motifs.

Height 19 cm
WA 1989.99. Bequeathed by Miss Elizabeth Watt

Bibliography:
Annual Report 1989–1990, p. 27; F.Marcilhac, *René Lalique 1860–1945 maître-verrier. Analyse de l'oeuvre et catalogue raisonné* (Paris 1994), p. 417, no. 900. For a comparable example in greyish-green glass in the Rijksmuseum, Amsterdam cf. P.C.Ritsema van Eck and H.M.Zijlstra-Zweens 1993, p. 357, no. 520

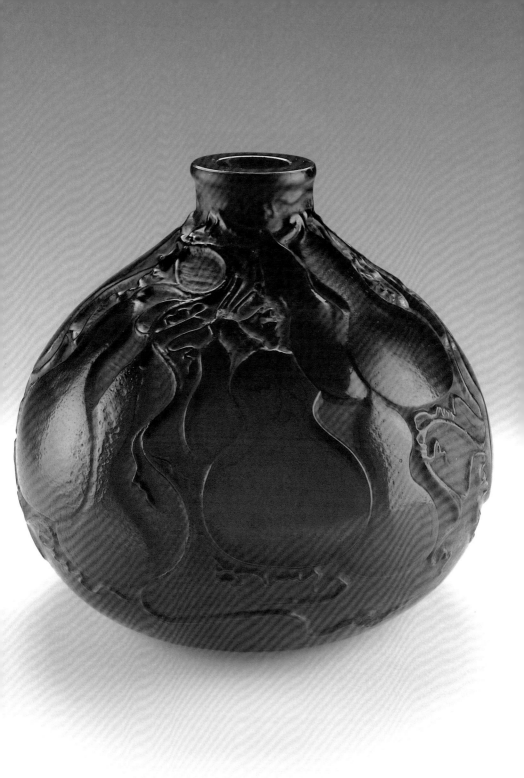

56 The 'Finzi' bowl
 Laurence and Simon Whistler, dated 1981

This contemporary bowl, probably blown at the Whitefriars Glass Works in London, was stipple-engraved in honour of the composer Gerald Finzi (1901–1956). It was commissioned by Shirley Carson and was presented to his widow, Joy, at the Finzi Trust Celebration of English Music held at Ellesmere College, Shropshire, in 1981. The technique of stipple-engraving was a revival of the 18th-century art as practised most famously by Frans Greenwood (1680–1761) and David Wolff (1732–1798, cf. no. 49).

The bowl was engraved by Laurence Whistler and his son, Simon, and their initials (LW and SW) and the date 1981 appear above the arch of the brick porch (see below). The pictorial work, engraved by Laurence Whistler, includes depictions of Gloucester Cathedral and the Church of St Bartholomew on Chosen Hill above Churchdown, between Cheltenham and Gloucester, both important monuments in Gerald Finzi's musical career and personal life. The musical scores, engraved by Simon Whistler, come from settings by Finzi for poems by Shakespeare, George Peel, Ralph Knevet, Thomas Hardy, Thomas Traherne, William Wordsworth and Robert Bridges. Around the foot of the bowl is a quotation in Finzi's handwriting from a letter he wrote about the authors whose work he had set to music,

'To shake hands with a good friend
over the centuries is a pleasant thing'.

Height 20.4cm; diameter 23.1 cm
WA 1982.190. Presented by Mrs Joy Finzi

Bibliography:
J.M.Popkin, *The Finzi Bowl* (Oxford 1986)

Detail of the porch of St James's Church, Ashmansworth

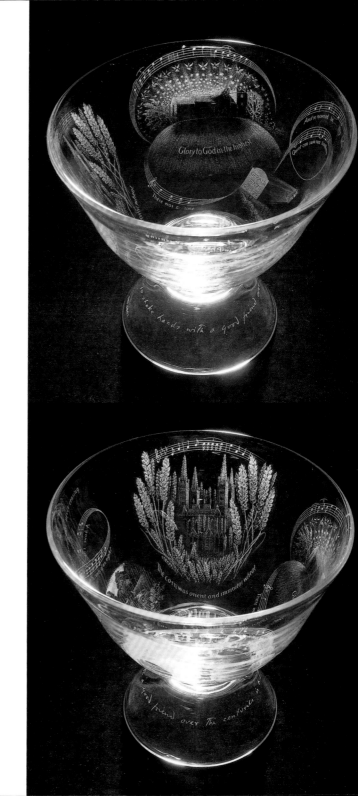

Bibliography and suggested further reading

General books on glass and museum collections

R.J.Charleston, *Masterpieces of Glass: A World History from The Corning Museum of Glass* (Corning, New York 1980)

R.Liefkes (ed.), *Glass* (London 1997)

H.Tait (ed.), *Five Thousand Years of Glass* (London 1991)

Ancient and medieval glass

E.Baumgartner and I.Kruger, *Phoenix aus Sand und Asche: Glas des Mittelalters*, exh. cat. (Munich 1988)

D.F.Grose, *Early Ancient Glass in the Toledo Museum of Art* (New York 1989)

D.B.Harden, H.Hellenkemper, K.S.Painter and D.B.Whitehouse, *Glass of the Caesars*, exh. cat. (Milan 1987)

P.T.Nicholson, *Egyptian Faience and Glass* (Princes Risborough 1993)

E.M.Stern, *The Toledo Museum of Art: Roman Mold-Blown Glass* (Rome 1995)

E.M.Stern and B.Schlick-Nolte, *Early Glass of the Ancient World 1600 BC–AD 50: The Ernesto Wolf Collection* (Ostfildern 1994)

D.B.Whitehouse, *Roman Glass in The Corning Museum of Glass. Vol. 1* (Corning, New York 1998)

Eastern and Islamic glass

C.Brown and D.Rabiner, *Clear as Crystal, Red as Flame: Later Chinese Glass* (New York 1990)

A.Contadini, 'Chapter 4: Glass', *Fatimid Art at the Victoria and Albert Museum* (London 1999)

M.Jenkins, *Islamic Glass. A Brief History*, Metropolitan Museum of Art Bulletin (New York, Fall 1986)

J.Kröger, *Nishapur: Glass of the Early Islamic Period* (New York 1995)

A.H.Morton, *A Catalogue of Early Islamic Glass Stamps in the British Museum* (London1985)

R.Ward (ed.), *Gilded and Enamelled Glass from the Middle East* (London 1998)

Renaissance and later European glass

R.J.Charleston, *English Glass and the Glass Used in England, c. 400–1940* (London 1984)

B.Klesse and H.Mayr, *European Glass from 1500–1800: The Ernesto Wolf Collection* (Vienna 1987)

D.Lanmon, *The Robert Lehman Collection, XI: Glass* (New York 1993)

M.S.Newby, 'The Ashmolean Museum, Oxford. Eckstein, Susman and Marshall – a collection of collections', in D.Watts (ed.), *Glass Collectors and their Collections in Museums in Great Britain* (London 1999), pp. 25–32

P.C.Ritsema van Eck and H.M.Zijlstra-Zweens, *Glass in the Rijksmuseum*, vol. 1 (Amsterdam 1993)

R. von Strasser and W.Spiegl, *Dekoriertes Glas. Renaissance bis Biedermeier* (Munich 1989)

H.Tait, *The Golden Age of Venetian Glass*, exh. cat. (London 1979)